Public Faces–Private Lives

Women in South Florida— 1870s-1910s

Public Faces–
Private Lives

Women in South Florida—1870s-1910s

Karen Davis

The Pickering Press

The Pickering Press
2575 S. Bayshore Drive, #3-A, Miami, FL 33133

© 1990 by The Pickering Press
All rights reserved. Published 1990
Printed in the United States of America
95 94 93 92 91 90 5 4 3 2 1

Library of Congress Cataloging-in-Publication Data

Davis, Karen, 1943–
 Public faces—private lives, women in south florida—1870s- 1910s / Karen Davis.
 p. cm.
 Includes bibliographical references (p.).
 ISBN 0-940495-22-8 : $12.95
 1. Women—Florida—History—19th century. 2. Women—Florida—History—20th century. 3. Women pioneers—Florida—History—19th century. 4. Women pioneers—Florida—History—20th century.
 I. Title.
 HQ1438.F6D38 1990
 305.4'09759—dc20
 89-27895
 CIP

Front Cover Photograph: Mary Sterling and her daughter Ethel of Delray Beach, Fla., in early 1900s.

Contents

Acknowledgments

Much of this book is based on papers, letters, journals, and photographs in the collections of the following institutions, which graciously gave me permission to publish excerpts: the Boynton Beach Historical Society, the Broward County Historical Commission, the Henry M. Flagler Museum, the Ft. Lauderdale Historical Society, the Historical Association of South Florida, the Historical Society of Palm Beach County, and the Lake Worth Historical Museum. I thank them all.

Other material came from descendants of pioneer families, who generously shared their family photo albums with me, let me browse through boxes of old letters, and, in one case, even took down clothes from the attic so I could see what a grandmother-in-law had worn. Special thanks to Pearl Calloway, Patty Catlow, Bessie DuBois, Henry and Pansy Harper, Barbara Hutchinson, Mary Gersh, Betsy and Vincent Gilpin, Jr., W. Frank Marshall, Steven Murray, Eleanor (Murray) DeSala, Ann Newman, Dr. Thelma Peters, Marjorie (Potter) Stewart, Mrs. Robert Powell, Dimick Reese, T. T. Reese, Fred Slater, Freda (Voss) Oyer, Elsie Welch, Bessie Wise, William S. Williams, and Yneta (Woods) Kiriwin.

The preliminary research for the book was funded by a grant from the H.F. Kaltenborn Foundation. Later, the Florida Endowment for the Humanities awarded

me a grant for additional research which became the basis for a slide/tape show and a poster exhibit.

I'm also indebted to many individual women— to those who wrote the papers I've used; to librarians and curators Dr. Nan Dennison, Becky Smith, Dawn Hugh, and Virginia Farace, who made research seem like a treasure hunt; to historians Mary Linehan, Arva Moore Parks, and Dr. Thelma Peters, who pioneered the field of south Florida history; to Suzy Glazer, Sandy Konigsburg, Susan Fishgold, and Sandie Levitt, who made me clarify my enthusiasm for pioneer women by explaining it to them; and to Flora Davis, my long-time mentor, who helped with rough drafts of the book.

It's been a pleasure— and a learning experience— working with Dr. June Pimm and Charity Johnson of The Pickering Press, and I am indebted to my editor, Mark Seibel.

Finally, this book would not have been possible without the support and encouragement of my husband, Gerald Davis. He patiently read chapters, cooked supper and took over carpool chores when I was too busy writing. As a professional photojournalist, he's responsible for the excellent photographic reproductions, and I'm grateful to him for showing the "public faces" of these women in the best light possible.

This book begins with women who lived in the nineteenth century. It's dedicated to my daughters Ariella and Vanessa, born in the twentieth century, who will be pioneers in the twenty-first century.

Karen Davis
West Palm Beach, Fla.
August, 1989

Introduction

After settling into their permanent homestead in south Florida in 1873, Margretta Pierce and her nine-year-old son lived for two weeks on only pumpkin and fish while her husband sailed north for provisions to Titusville, 160 miles from the family's Lake Worth home. Three years later, a neighbor, Mrs. David Brown, walked more than five miles of sandy beach on a hot August day to help Margretta in childbirth. Mrs. Brown came too late for the actual delivery, but she stayed to help Margretta recover from what probably was puerperal or childbed fever.

Further south, Mary Munroe arrived in Coconut Grove in the mid-1880s. She wrote that the mosquitoes were so bad that she had to crawl into bed under "bars" or mosquito netting to read her letters comfortably. A decade later, Florence Miller, a farmer's wife from Arch Creek near Miami, described how her husband put fertilizer on their horses' legs to keep the mosquitoes from biting them.

Even as late as 1896, Mary Sterling was surprised when she arrived in Linton, as Delray Beach was called, expecting to find a town. Instead, she saw hardly anything but the general store her husband had opened a few months earlier. The rest of the landscape was scrubby palmettos and deep white sand. The Philadelphia matron had to overcome her impulse to take the next wood-burning train back; eventually, she

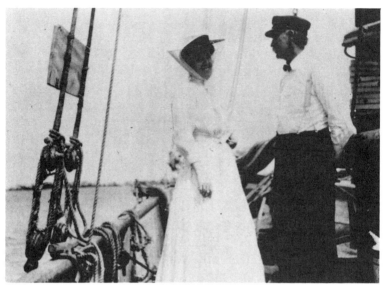

Etta Moore and her husband, Capt. Uri D. Hendrickson, aboard their schooner, the "Emily B," circa 1887.

even adapted to cooking outdoors using palmetto roots for fuel.

Most people don't connect south Florida with pioneers, much less pioneer women. But settlers and visitors began coming to the areas on Lake Worth and Biscayne Bay as early as the 1870s and 1880s. By the 1890s, more settlers streamed in as Henry Flagler pushed his Florida East Coast Railroad south until it literally reached land's end in Key West in 1912. As the tracks were extended along the seacoast, laborers came, families followed, and communities sprang up. While it was the men who broke the ground and laid the train track, it was the women who made homes for their families in this semi-tropical wilderness and who started schools, churches, and other social institutions.

These Florida pioneers may not look much like characters in a John Wayne western. There were no covered wagons, stampeding buffalo, or prairie madonnas in poke bonnets and calico aprons; no marauding

Indians, blinding blizzards or dust storms; no attacks by wolves or mountain lions.

Boats were used for transportation, and women and men wore bathing suits as early as 1885. The Seminoles hadn't been a threat since they had been "pacified" and sent to Oklahoma reservations or back into the Everglades by the 1860s; their appearance may have startled the pioneers, but the Indians were more respected for their skills as hunters and traders than feared for anything.

There were snakes, alligators, panthers, and periodic hurricanes, but the real hardships came in small ways on a daily basis—persistent mosquitoes, ticks, fleas, ants, heat and humidity. The pioneers had to cope with the isolation of living in a part of the country so remote that it took two weeks for the outcome of Dade County's vote in the 1876 presidential election to reach Washington, D.C. Settlers had to doctor each other, and occasionally they had to be undertakers as well.

These south Florida settlers were no less brave or adventuresome than pioneers anyplace else as they carved out homes for themselves from palmetto scrub land and mangrove swamps. Despite geographical differences, the early women of south Florida shared two qualities with the pioneer women of the West: strength and a determination to make homes in a foreign, often hostile environment.

The public face of this period—from the 1870s to about 1912—has been documented in history books and photographs. But another way to learn about these early experiences is to look at the journals, letters and personal papers of these women. In writing about daily life, sometimes with intimate detail, they reveal not just the public face put on for the camera but their private lives as well.

My fascination with these private lives began with an exhibit of nineteenth-century clothing at Palm Beach's Henry Flagler Museum one muggy August afternoon. I

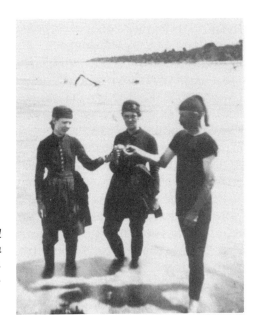

Misses Hattie and Nellie Gale in a Palm Beach bathing scene, circa 1885.

wondered how Victorian women coped with the vicissitudes of a Florida before air-conditioning, insect repellent, or even ceiling fans. How did they lace themselves into tight corsets, starched white linen and lace dresses, and then light black smudge pots at night to smoke away the bugs?

As a writer, I'd always looked for the "telling detail" that made a story or an interview come to life. As a student of history, I'd always been disappointed with the "great deeds" school of thought that focused on actions and heroes at the expense of ordinary people and the details of daily life. It's the "ordinariness" of daily life that's always made historical periods come alive for me.

The costumes I saw were displayed on dressmakers' mannequins. But I wanted to discover the women who had worn them. Ultimately, I found their journals and papers, and I heard Emma Gilpin, an early tourist here, snipe at *nouveau riche* millionaires who were ruining Palm Beach in 1893. I heard Daisy Lyman, a West Palm Beach schoolteacher in the mid-1890s, complain

about how hard it was to discipline children when they came from transient families, and I heard Della and Delia Keen commiserate with a Miami friend about the lack of birth control.

Curiously and wonderfully, all these voices sounded like conversations I hear today. Teachers still have to deal with migrant children; there's still no reliable, safe birth control; and the rich, as well as the poor, are still with us. But it's more than just issues that excite me in these papers; it's the tone, the nuances, the personalities of the women who wrote them. More than 100 years ago, in many cases, they wrote to friends or just wrote things down on paper to relieve their own feelings. Today, these words reach through time and speak to us clearly about the early days in south Florida.

I began this project with the hope of including the journals and papers of all types of women— not just the letters of the Victorian matron visiting the Royal Poinciana in Palm Beach, but those of the hotel maid as well; not just the diaries kept by daughters of Miami businessmen, but also those kept by wives of black Bahamian laborers. But in the nineteenth century, literacy was not as widespread as it is today. And even if a woman knew how to write, not all had the time to do so.

In these papers, we do hear from women of leisure like Emma Gilpin, and from farmer's wives like Maude Holtslaw or storekeeper's daughters like Stella Budge. We hear from scared, lonely young wives and from more experienced women who knew how to make a cake with water instead of milk; from schoolgirls and from schoolteachers.

But there's a whole group of "lost" women we don't hear from: Seminole women who didn't learn the English alphabet until the twentieth-century, servant-class whites, and blacks. They had neither the time nor the skill to leave behind a written record. Nor do any personal papers remain from the best known south Florida women: Julia Tuttle, who supposedly lured

Henry Flagler to Miami by sending him orange blossoms as proof that south Florida was frost-free, and Mary Lily Flagler, Henry's wife, who held court in Whitehall, the $4 million mansion he built for her in Palm Beach in 1901.

In some cases, interviews with descendants of early women settlers have helped to fill in gaps in their histories. But because women have so often gone unheard in the past, the emphasis in this book is on letting them speak for themselves and not having anyone else "tell" their lives for them.

I found these papers in family possessions, private collections, and historical libraries throughout south Florida. Most have never been published before. To aid the reader, some paragraph indentation, commas, and periods have been added. In most cases, original spelling has been kept both as a reflection of the Victorian period and of the woman's schooling or lack of it. Editorial explanations have been inserted within [brackets], and gaps in the manuscripts are shown with ellipses . . .

The 1870s

U ntil the early 1870s, south Florida was as much an underpopulated wilderness as any territory in the western United States. In 1870, a mere eighty-five people, according to U.S. Census records, made their homes in Dade County, the vast semi-tropical tract that stretched from north of Lake Okeechobee south to the upper Florida Keys.

The land that eventually became Martin, Palm Beach, Broward and Dade Counties had many environments: scrubby pine and saw palmetto growing on dry plains; grassy marshlands filled with sedge and sharp saw-grass; jungle-like thickets of mangrove swamps that edged up to the sandy shoreline; and rich hammocks where bromeliads and wild orchids dripped from tall trees. Two large bodies of water featured prominently along the coast. Toward the north, Lake Worth—more a lagoon really than a lake since tides from the Atlantic Ocean filled it with salt water— divided the mainland from a string of barrier islands, part of which would become Palm Beach. Toward the south, Biscayne Bay, more than 50 miles long, curved around what would become Miami and Coconut Grove.

Neither sixteenth- nor seventeenth-century Spanish *conquistadores* and missionaries had found the land worth settling, a judgment shared by English explorers. By the eighteenth-century, Bahamian seamen who fished the waters knew the coast and the Florida Keys,

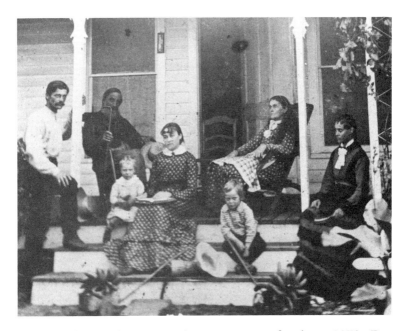

Early Lake Worth settlers: the V.O. Spencer family, in 1879. By the end of the 1870s, more settlers were coming to the Lake Worth area and putting down permanent roots.

but only Key West, at the southernmost tip, thrived—first, as a base for pirates who preyed on ships off the Straits of Florida, then, after Florida became a U.S. territory in 1822, as a home for legitimate salvagers who saved lives as well as goods from ships that foundered off the Florida reefs. The rest of south Florida slumbered.

That wasn't so in Florida's north and central regions. Settlers from Alabama, Georgia, and the Carolinas had begun pouring in after the U.S. acquired Florida from Spain. Their pastureland and farms pushed the native Indians south or into the interior. The Seminoles fought back in 1816 to 1818 and again from 1835 to 1842, bringing U.S. soldiers into Dade County, where they established Ft. Dallas in 1837 on the mouth of the Miami River.

After the Seminoles' defeat and Florida's statehood in 1845, some former army scouts and suppliers

An 1886 photo of Pierce family home on Hypoluxo Island in Lake Worth. L-r: Margretta Pierce; her husband H.D. Pierce; post-master A.W. Garnett; Ed Hamilton, the barefoot mailman who died in the line of duty; Lillie Pierce; her brother Charles.

stayed on along the shore and to the north of Biscayne Bay. Together with a few salvagers who moved up the Florida Keys and the families of the men who kept the lighthouses during the Civil War, they were the nucleus of Dade County's early population.

In the years immediately following the Civil War, when much of the country was on the move, the first true wave of settlers arrived, coming for the same reasons people come today: economic opportunities and the salubrious effects of exchanging cold, snowy northern winters for sun and warmth.

The region was still remote, and travel to it was difficult. There were vast uninhabited stretches of land, and neither the climate nor the insects and wildlife made life comfortable. But people, very often from the Midwest, came as pioneers always do, to improve their lives.

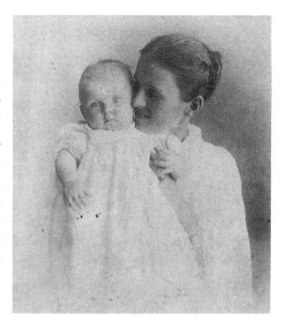

*October 1897—
Mrs. Lillie Pierce
Voss, 21 years
old, and her one-
year-old daughter
Lilian Frederica
(Freda) Voss Oyer.
Lillie is wearing
the wedding dress
she made; in the
course of sewing
it, she supposedly
got bored and
went out duck
hunting.*

Margretta Pierce, Marion Geer, Fanny Brown, and Anna Bonker all arrived in the Lake Worth region, as the area south from Jupiter to Hypoluxo Island was called, in the 1870s, and they probably knew each other although they lived far apart. Three were wives and mothers, one a young woman. Their stories share similar themes: the hardships of travel; the loneliness and remoteness; and the ever-present, ever-annoying bugs. But despite that commonality, they all responded differently: Margretta with quiet stoicism; Marion with humor and ingenuity; Fanny with despair; and Anna, the youngest, with exuberance.

Margretta and Hannibal Pierce and their eight-year-old son, Charlie, were the first family to settle in the Lake Worth region when they arrived in 1872. Hannibal had been a sailor on the Great Lakes before moving his family from Chicago. In Florida he homesteaded land, worked odd jobs such as scavenging and selling copper sheathing from shipwrecks. Later he became a station-keeper at some of the coastal Houses of Refuge set up to rescue shipwreck victims.

Because Margretta's diaries were destroyed, her experiences come down to us in unpublished accounts written by her daughter, Lillie Pierce Voss, between 1912 and 1940. Lillie, who was born in 1876, begins one draft by saying, "I was the first white girl born between Jupiter and Miami when the whole country from Jupiter to Miami was nothing but a howling wilderness."

Through her words we learn not only about the difficulties of her mother's life but also about the freedom and happiness of her own childhood. "Mother was never very strong after [my birth] and the hardships of pioneering were never easy for her. She never complained much but was always wishing for three things which were not procurable here: beefsteak, cow's milk, and buggy rides."

Simple as these wishes seem, they were unattainable in the 1870s and 1880s because the heat and insects made keeping cattle for dairy or beef impossible, and the lack of roads made keeping a buggy ridiculous. It would only be in the 1890s that some of Margretta's wishes would be satisfied.

"After I was grown and married and Mother lived with me for several years, and as the Lake was now rapidly settling up, she came to realize her dreams as cows were being kept and good roads being built."

Lillie was the last of seven children her mother bore. Only she and her older brother, Charlie, survived past infancy. Using her mother's recollections, Lillie describes what life was like in 1872, before Lillie was born, when her family first arrived at her uncle's place on the St. Johns River, south of Ft. Pierce:

[It was] seven miles away from anything but mosquitoes; they were there by the millions. My parents lived in a Palmetto shack, which means a light framework, over which the fans or leaves from the Palmetto trees are nailed, overlapping each other like shingles. When new, these "shacks" are pretty, light green in color and

clean, but an old one is brown, leaky and full of roaches and very frequently a house snake a couple of feet long lives in the roof to catch roaches; the windows and doors of these pioneer houses were wooden shutters.

One day my mother hung the mosquito bar or netting used over the bed out on the bushes to air, along with some of the bedding, and went with Father to a different location where he was building a new shack, and when they returned they found only ashes to mark the spot of the old shack. Their clothes were all gone, and practically everything but the mosquito bar, which was providential, as the mosquitoes would probably have killed them in one night's time, they were so thick.

Returning to Ft. Pierce, her father was soon hired as an assistant keeper by Captain James Armour of the Jupiter Lighthouse, so the family moved there.

The nice whitewashed Government buildings looked so good to my folks, who had been so long out of a house, and Father told Mother it was like jumping out of Hell into Heaven.

Despite the companionship and financial security of working at the lighthouse, the Pierce family decided to move further south to Hypoluxo Island in Lake Worth.

October 1873

I don't know why they didn't stay there [at Jupiter]—that's always puzzled me. They had pretty near everything but also plenty of sandflies. But the Lake Worth country was opening up then . . . and people who came down came back with glowing descriptions . . . My father came down to the south end of the lake and Hypoluxo was very beautiful at that time. It had a growth of dog fennel which is feathery, fine leafy stuff. [It] grew about four feet high all over the lower land and morning glories were all over

that. My mother said it was very beautiful so he homesteaded the south end of Hypoluxo Island and my Uncle Will homesteaded the north half.

The lake was twenty-two-and-a-half miles long so there was forty-five miles of shoreline—just think of it—forty-five miles of lakeshore without any habitation on it except one log house up near where the first Bethesda Church was built [on Palm Beach] which belonged to an old beachcomber, Charlie Moore . . .

Mother pioneered here cooking for a year under a big "Rubber Tree" in the front yard, and using a Dutch oven to bake in. There was plenty of game of every kind, Bear, Deer, Turkey, and the water was full of Fish and Turtle . . . but Father had to go clear to Titusville, 160 miles, for provisions of any kind and the trip usually took from three to four weeks. On one of those trips my mother and brother, at home, lived on Pumpkin and Fish and nothing else for two weeks.

Lillie's description of growing up on Hypoluxo Island makes it seem like paradise for a child, even with the summertime mosquitoes:

[It] was a delightful place for a youngster to grow up—water right down by the back door. We were just a little bit away from the lake on the back side and a lagoon where I could go in bathing and wading. My cousin in Chicago sent me a lovely pair of morocco [leather] shoes—red morocco shoes, the first shoes I had ever seen. Mama put them on my feet and I waded in the lake with them to see if they'd wade. They did.

. . . During the summertime . . . there were a few million mosquitoes to the square inch. We stuffed up our key holes and every crack. We went around before dark and killed those mosquitoes off the windows and then we didn't light any lamps. But my brother had a violin and he'd

sit there and play and mother and father and I would sing. So we spent many an evening singing old songs.

The Pierces made the best of adversity and did it themselves as they lived in isolation at the tip of Hypoluxo Island.

Marion Geer's arrival four years later on an island twelve miles north was not so lonely. She was part of a group of thirteen members of the Dimick and Geer families who arrived on Palm Beach in 1876. Marion writes with a touch of sarcasm about the vision that drew her husband, Albert, and her other relatives to the Lake Worth area.

[It was] a "Garden of Eden" where the sky was bluer, the water clearer, the flowers sweeter, the song of birds more musical than anywhere else on the continent. Could mortal woman ask more? . . . We did not.

Marion's story, written in 1896 for the *Lake Worth Historian*, lacks immediacy. But her lively writing in this souvenir journal "published by the ladies of Palm Beach for the benefit of the Royal Poinciana Chapel" makes up for the longer perspective.

The Dimick and Geer brothers and sisters married each other, and under the leadership of patriarch M.W. Dimick, they set off on their journey south by railroad in December, 1875. Their reason was simply the weather:

Our home had been on an Illinois farm: . . . When the mercury has taken up winter quarters down at the bottom of the tube; when the windows are so filled with frost that looking out is impossible for days; when the winds come sweeping over the prairie gathering force with every mile, shaking doors and windows, shrieking and howling around corners as though a host of

demons had been let loose; when the blinding snowstorms come, blocking roads, burying fences out of sight and bringing general discomfort; and when at last spring comes with its interminable mud, deep, black, and sticky, the climax has been reached and the desire for a change to a more genial locality cannot be wondered at.

Leaving Jacksonville in September 1876 for the three-hundred-mile mile journey south to Lake Worth, the group took a steamer up the St. John's River to the western edge of Lake George. There, they transferred to a mule-drawn wagon for an eight-mile ride over palmetto roots and deep sand to Titusville. So cramped was the wagon that Marion writes:

> After contracting our dimensions to fit the space allowed us, still there was no room for my husband's feet and he obligingly left them outside.

At Titusville the party transferred to a sailboat for a one-hundred-thirty-mile ride down the Indian River to Jupiter. From there, they had a choice of sailing ten miles on open ocean or poling, pushing and rowing a boat across eight miles of sawgrass to the northern edge of Lake Worth.

During their voyage down the Indian River, Marion learned at least two things. The first was that she and her husband weren't good sailors:

> The size of the boat made it necessary to sleep standing up, else take turns lying down; and the pounding of the waves was not a soothing lullaby in our ears.

The second was that she and other Floridians to follow were going to have to share the land. Putting up one night on the shore at Eau Gallie, she writes:

> The discomforts we had found on water were fully equalled on land by the swarms of mosquitoes above us and the great black ants under us which seem to have pre-empted the land and

were not hospitably inclined toward late-comers.

The next day a sailor taught her that a smoking smudge pot and a cheesecloth canopy hung over a bed could keep some insects away.

The next night we took refuge in a shanty made of palmetto leaves, where the mosquitoes were numerous and persistent for, shut out by the canopies surrounding our beds, they came in squads and battalions through the cracks in the floor. It began to look as though snow and mud were not the only foes to human comfort.

Appearances were also deceiving when they finally reached the island of Palm Beach:

Our "Garden of Eden" . . . Oh desolation! What a place to travel weary days and nights to find! There seemed absolutely nothing to build our hopes upon, surely not the thin soil with the Coquina rock cropping out everywhere, giving no security to the native trees and there they lay all around us uprooted by a tornado which had swept over the state sometime before.

Still, within three weeks the group had cleared some land on the lakeside of Palm Beach near the present Clarke Avenue and built a house. But shortly afterwards, the hurricane of 1876 struck:

. . . table, stove, chairs and bureau were blown about and dropped far and near, which was not in accordance with our ideas of the gentle zephyrs we had been told fanned the cheeks of those who lived in this favored region.

Being anxious that Lake Worth should, as soon as possible, take on the appearance of a flourishing settlement, as well as for our own convenience, we planned to build two more houses. A large boat was chartered in which building material could be brought from Jacksonville. With the load were shipped chickens and a mule.

The next few weeks were spent in cutting

foundation timbers, shaving shingles and building. How proud we were when "finis" was written upon our work and with what satisfaction we hastened to settle those new homes!

No matter if the carpets did not go around and we had to improvise a chair or two when the neighborhood went visiting. Those we had taken with us were considered too extravagant and luxurious for ordinary use and called forth many expressions of surprise: "What cane-seated chairs! and glass windows!! What next?" (most of the settlers being satisfied with wooden shutters.)

With the nearest post office being sixty-five miles north at St. Lucie, months elapsed between mail days, and the settlers were isolated from news of home and the nation. Mrs. Geer writes that news of President Garfield's death reached the islanders only because a passing steamer threw a paper to one of their boats. It wasn't until 1880 that V.O. Spencer opened the first post office at Lake Worth, and "with mail once a week we felt as though we had emerged from darkness," writes Mrs. Geer.

The settlers were also far removed from the nearest grocery and dry goods store at Titusville, 130 miles away, so like the Pierces before them they had to wait for shipwrecks which jettisoned supplies or landed on shore.

Sometimes the generosity of the waves appalled us; we needed lard and seven barrels came, 2,800 pounds! We needed kerosene and cans of it were washed ashore: along with it came boxes of bacon and tobacco and cans of turpentine and varnish. Sails came too, which when cleansed from the salt water furnished duck suits not to be despised by anyone. In that hot climate we thought longingly of our northern cisterns, plentifully supplied with soft water, when lo! an iron buoy rolled in, and after some manipulation

from Mr. Geer we had a cistern of six or eight barrel capacity.

By 1878 the family had begun farming and shipping tomatoes and other produce north, but the women had their own sideline:

While the fruit and vegetable business was being carried to a profitable finish by the men, we, the busy housewives, found ways to "turn an honest penny." Among the settlers who had located since our arrival were about thirty widowers and bachelors for whom we served. We hesitated at nothing from a "wamus" [a rough jacket] and overalls to a dress suit. Possibly the style of our garments would not have been acceptable to the 400 of a fashionable city, but our customers had abundant confidence in our ability as tailors, so we had a "corner" on the gent's furnishings department also. We bought our goods by the bolt at Jacksonville, and no one could envy his neighbor for the superior cut and quality of his clothes. Our millinery department also became popular, as we soon learned to split, bleach and braid palmetto leaves and sew [them] into any size and style required.

During these early days, the settlers lived well off the land and sea. Still, Marion writes of missing some culinary treats:

In the early years our tables had something of a lean and hungry look, lacking the variety we had been accustomed to in the North. We missed the picnic cakes, those dainty confections compounded of the whitest of sugar, butter, eggs and milk which ingredient, alas! we had learned to do without, for we had not yet discovered a way to keep our animals from the ravages of mosquitoes. Mrs. Moore very kindly taught us many ways of substituting water for milk in cooking, and however well it did for cake, we never could convince ourselves that a few

spoonfuls of it took the place of thick, yellow cream in a cup of coffee.

Marion admits that she writes through "the mists and shadows of twenty years" and that time has a way of modifying memories. But neither time nor distance dimmed the bad memories Fanny E. Brown had of her pioneering days.

Writing for the same *Lake Worth Historian* in 1896, Fanny drew from excerpts of letters she wrote while at Lake Worth during 1876. Fanny never names her husband, her children, nor the location of her home on Lake Worth; all we know is that she writes from Port Townsend, Washington, her new home. After describing a particulary uncomfortable and slow journey down the St. Johns and Indian Rivers, especially at Mosquito Inlet ("The horrors of that night none of us will ever forget. The place surely justifies its name."), she has an equally inhospitable arrival on Lake Worth.

It grew very dark, and the rain was falling fast. We could only tell our distance from shore by the flashes of lightning, which, fortunately for us, were very frequent. One thing we were sure of, we should meet no one, as few travelers were using this highway. It was a three mile "pull" to our landing, but I am sure our unaccustomed oarsmen made it many more.

At last a light; it must be the campfire of our one neighbor, and such it was. We paused at his landing to speak and engage his help, and also that of any one else he could get. I chanced to ask some question, when a voice in a greatly surprised tone, said, "Why, that's a woman's voice!" The reason for surprise, I was told, was, that with the exception of myself there were but two women for many miles around.

At our own landing . . . lightning revealed [the house's] location, and we scrambled over rocks, bushes, and flower beds to the steps . . . Shelter was most welcome, though the house was so

close and stuffy we could hardly breathe. I
opened the windows for fresh air, but alas for my
ignorance, the one small lamp was enough to
draw myriads of mosquitoes to make music and
torment us. Fortunately the two beds in the
house were covered by good bars [mosquito
netting], so the experiences of Mosquito Inlet
were not repeated in every particular . . . Two
days later, the schooner unloaded, windows and
doors screened, we made ourselves as comfort-
able as possible.

But she never really felt very comfortable or secure:
Alone with the children one evening, weeks
later, our reading was interrupted by the most
piercing scream, repeated two or three times,
seeming to come from the very doorstep. J.
caught his gun, opened the kitchen door, saw
two gleaming eyes and fired. The creature ran by
the window, near which we were sitting, and the
thud of its feet sounded as if made by an unshod
horse. In the morning the footprints were pro-
nounced to be those of a large panther. Another
visit from one came some time later. L. came in
from the swing saying, "I saw a big dog out there,
and swung close to him." There was no dog on
the Lake but our own little Majie: and again the
visitor was known by its footprints.

So the old records go on, from week to week,
telling of loneliness and isolation, when I saw no
face, save those of my own family, for more than
a month at a time. Here, in my new Western
home, they but serve to assure me "it was not all
a dream," but a stern reality.

Fanny's isolated life is entirely plausible when you
remember that Lake Worth had almost forty-five miles
of lakeshore. Without roads, you could go days without
seeing anyone unless you built houses close to each
other, as the Geer and Dimick families did.

If Fanny Brown's memories describe a harsh life

here, Anna L. Bonker's do not. One reason may be that Anna came to Lake Worth as a carefree young woman, not as a mother with responsibilities. Another reason may be the social life she had as a member of a large, extended household of many families and visitors.

Anna came to Lake Worth as a college girl in 1876, and she wrote in the *Lake Worth Historian* twenty years later under her married name. Her maiden name was Brown, apparently no relation to the lonely, unhappy Fanny Brown. It was Anna's father who had offered temporary lodgings to the Dimick-Geer party when they first arrived on Palm Beach, and her mother had befriended Margretta Pierce when she helped Margretta recover from giving birth to Lillie.

Anna's description of those early Lake Worth days reveals an adventurous spirit that breaks down stereotypes of what Victorian young ladies did and did not do. Sailing down from Titusville to Jupiter with her father and a small crew, she wasn't bothered by camping out even though it meant "having your food seasoned with sand instead of pepper and salt." Her whole air is one of bravado:

> I was not at all afraid, as the boat was managed by an excellent sailor, and I had a certain spirit of recklessness and daring, which the young usually dignify by the name of courage.

> And so I reached my home . . . hungry, worn out, and my face like a boiled lobster from the sun.

> My father's house was, at that time, by far the largest on the lake. A great hall, sixteen feet wide, ran from front to back, with large rooms opening on either side, and a repetition of this plan on a floor above. And oh, most curious, a thatched palmetto roof! In all ordinary storms this roof proved as tight as a drum, and no drop of water came through.

> In this house were living several families; friends who had bought land on the lake and

were making preparations for future homes. Life was hilarious, music and games during the evening; boating, bathing, hunting and beach-walking filled each day.

Unlike heroines of nineteenth-century novels who are often pictured languishing in parlors, Anna Bonker seems to have had a hearty spirit and a keen inquisitiveness about the natural world around her which, it appears, her mother shared too.

> I was wildly enthusiastic about making collections of natural history specimens . . . and spent many hours pickling snakes, curious fishes, and bugs . . . My mother was quite an expert at catching the kinds she knew to be harmless. There was a special little black fellow in the shape of a snake who called forth our admiration. He had bright red and orange rings around his slim body and was very fond of gliding up the palmetto trees . . . and my mother would quickly seize him firmly with her fingers just at the back of his neck . . .

Any snake could be caught in this fashion by a person who possessed the requisite nerve.

When the hurricane of 1876 struck, Anna's family was sheltering the Dimick-Geer families, who had just arrived on Palm Beach, and Margretta Pierce, who had come to recuperate from childbirth with her infant daughter, Lillie, and son, Charles. Anna writes:

> The wind came up about four o'clock in the afternoon, and rapidly increased in fury until about midnight. No one thought of going to bed. We listened to the wind tearing through the upper part of the house, and sounding like cannon balls rolling back and forth over the floors. The house swayed somewhat, but being well braced, showed no signs of giving way. The water of the lake was lashed into a phosphorescent flame, and when the men thought of looking after their boats they wound their arms

around each other to enable three or four of them to walk down to the shore. They could not withstand the wind, however, and gave up the attempt, and some of the boats were destroyed. At midnight the rain came down in literal torrents and we moved from one room into another trying to keep dry. The daybreak was a welcome sight.

The next morning we found several of our finest trees either broken off or twisted up by the roots, but no serious harm was done on the lake as there was so little there to damage . . .

[A] delightful relic of the hurricane was a gorgeous flamingo, supposed to be blown over from the opposite islands [the Bahamas], as it was the only one ever seen on the lake.

We removed and dressed the skin with the greatest care not to soil the beautiful plumage. Oh, the color of those lovely feathers, never forgotten if once seen! All shades of the most gorgeous red, in which were found suggestions of yellow, making every possible color of flame. On my return to the North I had a muff and skating cap made out of it, which I wore in state, and to the envy of all my girl friends.

Anna left the lake because of her schooling and, later, her marriage. But Lillie Pierce, the infant girl who weathered that hurricane with her, grew up on Lake Worth. Like Anna, Lillie was physically active, a tomboy who went duck-hunting and roamed the lake's shores. Lillie had no formal schooling and much narrower parameters to her life, but she was intelligent and sensitive to the beauty around her. Settled into motherhood at twenty-one years old, she still yearned sometimes to be free and connected to a larger, outside world as this lyrical description of the shipwreck of the "O Kim Soon" suggests. Lillie had been living with her parents at the time while her husband was away on business.

My father called me from a sound sleep early on the morning of January 30, 1897 saying, "Girl, there's a wreck on the beach." I jumped out of bed, shoved a pillow in front of my three month's old baby girl and dressing hurriedly rushed to the east porch where close against the narrow hill dividing the Lake and the Ocean there were to be seen the three spars and lower topsails of a vessel: they seemed to be steady and occasionally the spray from the sea would fly up into her royals which were furled.

It was a wondrous sight—white against the morning, contrasting deeply with the rainy northeast blow of the night before.

To me, a ship was something out of another world, alive, vital and different—a connecting link with the great ports of the world, and I felt much as tho a picture had come alive before my eyes . . .

The 1880s

When Mary Barr Munroe arrived at Coconut Grove in 1886, she faced both advantages and disadvantages in comparison to the women who had preceded her a dozen years earlier on Lake Worth, seventy-five miles to the north. On the plus side, she came to a community which had already been established by the families of lighthouse-keepers and seamen.

About half-a-dozen wooden houses had been built on the western shoreline of Biscayne Bay almost directly across from the lighthouse at Cape Florida. They were scattered along a slight ridge that sloped gently down to the water. Here, as farther up the coast, there were marshy mangroves lining the shore, tropical hammocks with live oaks and fern, and piney woods. The dense growth sheltered wildlife—panther, raccoons, deer, and snakes—but there was also the beginning of a rich social life centering around the Peacock Inn, also called the Bay View House.

Built in 1883 by Isabella and Charles Peacock and their family, it was the Bay's only hotel, and it also housed the post office where people came to socialize as much as to get their mail. In this two-story building with a three-sided porch overlooking the water, Mary Munroe met the nucleus of a network of women she could have used for companionship and advice. There was matronly Isabella Peacock, who managed the hotel, and a younger group close to Mary's age: Matilda Pent, for

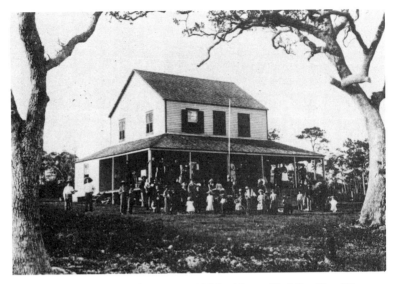

The Peacock Inn, Christmas 1886. Also called the Bay View House, this is where Mary Barr Munroe stayed when she and her husband Kirk first came to Coconut Grove.

instance, and the Frows—Josephine, Adelaide, and Euphemia—who were all married to sailors, carpenters, and starch-makers, as the people who ground the roots of the wild zamia or coontie palm for arrowroot starch were called.

But Mary's journals suggest she felt a disadvantage in having no strong function of her own which initially, at least, outweighed the benefit of arriving in a settled community. Mary came as a childless, thirty-four-year-old bride of two years. With no family to care for and no home to be responsible for that first year, Mary was just an adjunct to her husband, Kirk, a famous author of boys' adventure stories. When he went away sailing, even that wifely role felt diminished.

Mary's view of herself may have also been affected by her mother, Amelia Barr, who had fifteen children and was a prolific novelist whose romances sold to a mass audience. Amelia's opinions on women's roles were strong and traditional as this newspaper interview shows:

Mrs. Isabella Peacock, early resident of Coconut Grove and manager/co-owner of the Peacock Inn, circa 1883.

Women cannot keep young without children. It is the children that keep a woman ever youthful and make her retain her interest in youth . . . Business women grow old in mind quickly and it shows in their faces. Women are not built for business, primarily, and when they enter it, they are likely to become masculine, more coarse in their manner and feelings.

Perhaps to compensate for her lack of children, Mary later founded a girls' club, the Pine Needles, and was involved in taking care of many black children.

Mary's unpublished diaries are one of the most complete records of early south Florida life. But they record more than the comings and goings of visitors or the founding of Coconut Grove's social institutions such as the Biscayne Bay Yacht Club, the Sunday School, and the Housekeeper's Club. They also trace Mary's evolution from an insecure, new wife and an uncomfortable visitor to a valued resident. Mary

became so influential that she supposedly was responsible for Americanizing the spelling of Coconut Grove from the Anglicized original, Cocoanut Grove.

Mary and Kirk Munroe came to Coconut Grove from the northeast; Mary's early journals show them arriving each year in January and leaving some time around June. Kirk apparently supported them on his income as a writer: he was voted the most popular children's novelist at the 1893 Chicago World's Fair and also was an editor of *Harper's Young People* magazine.

They were drawn, as others were, by the beauty of the "transparent waters of the Bay [with its] bottom gardens of seaweeds, sponges, and fish," as one 1890 visitor wrote. In those pre-railroad days, people reached Biscayne Bay by traveling on a steamer to Key West, a thriving city with a population of about 18,000 people, and then sailing 150 miles north to the Miami area on small boats.

Mary's journal for 1886 shows a strong sense of displacement. She was away from her dominant mother and missed the emotional support of close family and friends. Part of her feelings come from the strangeness of her surroundings, but part may also have come from boredom. Until she and Kirk moved into their own home in 1887, Mary had little to keep her occupied.

Shortly after their arrival at the Peacocks' Bay View House, Kirk left Mary for what should have been a short cruise to Lake Worth to retrieve a sailboat he had left there the previous year. Kirk went with Ralph Munroe (no relation), a boat-designer and the founding commodore of the Biscayne Bay Yacht Club. Bad weather delayed their return, leaving Mary, who had no close friends at the hotel, feeling understandably apprehensive. The death of a hotel guest only heightened her anxiety over her own husband and emphasized her loneliness.

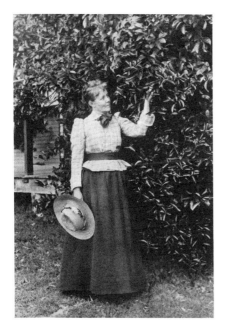

Mary Barr Munroe by a lime tree.

Thursday, March 11, 1886

A real cold morning . . . Mr. Peck grew much worse towards night and died at half-past or a quarter to six. God be merciful . . . No letter from Mama. Oh how I wish we were back in N.Y. [This last sentence is crossed out in the manuscript, perhaps as a form of self-censorship.] I did not mean it. I like Florida and M.M. [probably Mr. Ralph Munroe] in particular.

Friday, March 12, 1886

Up early . . . and saw them making the coffin for poor Mr. Peck. The neighbors began to gather and soon all were ready and he was carried [to] the grave. I followed the rest . . .

Oh, I wish Munroe [her husband Kirk, not Ralph] would come back.

Saturday, March 13, 1886

A letter today from Mama. Mrs. Peacock was taken ill and had to go to bed. The two Peacock boys went after Mr. Peck's things and they spent

the evening looking after his papers. A quiet uneventful day here . . .

My dear Munroe how I long for you to be back. God bless you.

Monday, March 15, 1886

Spent the morning mending and cleaning my clothing and washing my hair . . . I help[ed] Mrs. P. [Mrs. Peacock] take note of [Mr. Peck's] things. It is just dreadful. Death seems to have no fear in her for she is always talking about Him.

Tuesday, March 16, 1886

A lonely day. I spent the morning mending and cleaning my clothes, ironing and reading—and the afternoon pretty much the same—I am so tired of the people, their troubles and care . . .

Friday, March 19, 1886

The mail came but no mail for us. Oh dear how weary, weary I am and lonely. Watching and such miserable weather.

Monday, March 22, 1886

Awake very early. Mrs. Twitch [sic] called out that the sharpie was coming. I hurried up and dressed and she came but Kirk was not on her. Oh dear! I thought my heart would break.

Tuesday, March 23, 1886

. . . saw a small sail . . . and thought it might be the "Alligator" [the boat Kirk had left at Lake Worth the year before]. Watched it closely and it was . . .

Oh! I am so glad to have my own dear boy back. There is no one like him and he is so good to his girl.

The day after her husband's return Mary came down with an unspecified illness that put her to bed for a week. Her early journals show that she was sick on almost a monthly basis, suggesting perhaps "female problems" related to menstruation. While Mary writes often of feeling ill, only once does she specifically mention having the "grippe" so we never know whether her

ailments are polite euphemisms for being indisposed with her menstrual period, psychological ways of controlling Kirk and keeping him close by, or just the result of poor health in an uncomfortable climate.

Thursday, March 25, 1886

Up, but feeling so badly that I could not go to the breakfast table. When Munroe brought my breakfast I could not eat it and had to go to bed in great pain. Had taken cold and suffer a great deal. Munroe sleeping on the floor.

Friday, March 26, 1886

Better but feeling very badly. Changed my clothing and managed to read and sleep a bit but Munroe still sleeping on the floor . . .

Saturday, March 27, 1886

Better but still suffering. Got up and sat on a chair . . . [but] sleep pretty badly. Munroe came back to bed and that made me happier.

Monday, March 29, 1886

Got up after my breakfast and dressed and got downstairs. At the piazza met Mr. Munroe and Mrs. Lowe. It is my dear Mother's birthday. In the afternoon managed to walk down to the wharf Munroe went in the afternoon to see Mr. Morse and he sent me some mineral water, nitre and gin [?] and I began taking turpentine [commonly used to clean out the bowel and eliminate any intestinal parasites]. Went to bed early and had quite a night.

There were, however, some good days, when Mary took an interest in Kirk's business affairs and in the events around her.

Sunday, April 4, 1886

Was awakened by the mail carrier who came in very early and brought the news that nearly all Key West had burned down . . . the P.O. [Post Office], the bank, the hotel, and nearly [everything]. Kirk also received his release from the Mutual [probably a newspaper or a magazine]

and is once more a free man.

Tuesday, April 6, 1886

A lovely day. Munroe took me for a sail up to Punch Bowl and there I gathered mulberries, limes, and ate oysters.

Wednesday, April 7, 1886

A lovely day, doing nothing . . . all day. The Hines came up in the afternoon. I don't like them—Mrs. Hine, I mean—but then I don't like women anyway. [Thomas and Ed Hine owned a sharpie sailboat that was used for ferrying cargo and passengers to and from Key West.] Did not go sailing but just stayed around all day. The Frow children came over for a play in the afternoon.

Thursday, April 8, 1886

A lovely morning. I sat on the piazza all morning listening to Mr. Ed Hine [the younger and single Hine brother] play the banjo. The mail arrived bringing a letter from Mrs. Lowe [a Key West friend] about the fire but no official news and 2 [letters] from Mama.

At sundown a fire in the woods which has been burning for days [reached] such a head that they had to build back fires and all the men were out fighting it. The smoke is very bad and the fire very hot and . . . the boys were fighting it all night. I and [Mr./Mrs. ?] Hine went out to the stable and comforted the horses and we had a lively time for a while . . .

Mary's handwriting is unclear and it's not certain who was with her in the stable: the context would suggest Mrs. Hine except for Mary's stated antipathy towards her. Also, Mary inconsistently spells this family's name both with and without a final "s" throughout her journals.

Mary never again alludes to her dislike of women, and the rest of her entries for 1886 and the following years

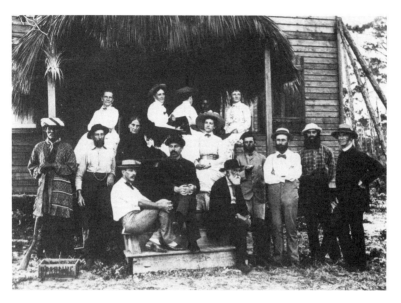

Friends of Kirk and Mary Munroe at their home "Scrububs" in 1887. Mary is in the back row with her back turned; Kirk is sitting on the left end of the porch steps in his shirt sleeves; and Commodore Ralph Munroe is standing next to the Indian.

suggest she overcame her initial antipathy towards Mrs. Hine. Instead, as she settled into pioneering in Coconut Grove she learned the importance of women friends. More than just social companions, they could be relied on for support, whether it was in saving a spoiled meal by sending over freshly baked bread or in nursing someone through illness.

When Mary and Kirk returned to Coconut Grove in 1887, they moved into their new home, the "Scrububs." Her journal this year shows the pride she takes in fixing it up. For the first time in Florida, she has a function to perform and she writes of the pleasures and frustrations of housekeeping in what must have been, at best, primitive conditions. Her competence at domestic skills, her growing circle of friends, and Kirk's constant presence at home all add to her new self-confidence.

Friday, January 21, 1887—The Scrububs
The first night in our own home. We had . . . tea,

marmalade, sardines, olives and bread on a table that Kirk made—the first piece of furniture that he has made. I busy all afternoon getting things in order . . . only one sharp jar broken and platter broken. Lamp all right . . .

Our colored boy William Henry Thompson [came over before noon and] Kirk put right to work. He seems a nice boy. C. J. Peacock is working for Kirk and altogether things look very pleasant. Kirk made a ladder box [probably a larder to keep food] today for the kitchen and put up shelves in there. The kitchen is so nice and the stove beautiful.

Saturday, January 22, 1887

I busy all morning with our kitchen pantry putting things in order. Had hot biscuits, molasses and coffee for breakfast; for lunch had tea biscuits, marmalade, and molasses and fried bread and for dinner boiled potatoes, fried ham, . . . pineapple, coffee.

Out all day in the kitchen. Got the front door hung and rafters up for dividing and the platform up between the house and the kitchen. [Many southern homes had separate structures for cooking to keep the heat away from the house.]

After dinner, Mrs. Munroe [Ralph Munroe's mother], Mrs. Nevins, Mrs. Sheppard, Mrs. Brown, and Miss McFarlane all called and we had a pleasant evening. Mr. and Mrs. Brown came over in the afternoon just at dusk. Kirk very tired but everything so nice. Like our boy very much.

Sunday, January 23, 1887

Up early—had our first meal in the House. B.B. Beans [Boston Baked] and bread [and] coffee—the Pent boy making a safe [a food safe for storage] for me in the kitchen. I busy with the trunks all morning. Mr. Hines and Ned Currie came about noon . . . I used my little tea kettle for

the first time with the lunch. Mrs. Peacock and
Mrs. B. both came over here. Mrs. P. sent me a
loaf of bread. We had for dinner just what we had
yesterday only the potatoes were fried and Kirk
had some wine. Our home is beginning to look
splendidly.

Monday, January 24, 1887

Kirk busy fixing the windows. Mr. P. making
the front porch. I busy with cooking and fixing.
Mrs. Frow and all her children over . . .

Got the curtains up and after dinner we hung
the pictures . . . The house looks so pretty and I
am just as proud of it as I can be. Kirk has been
so good to me and so helpful every way.

For the next few weeks Mary dutifully records the
meals she's cooked, the social calls she's made and
received, and the work Kirk's done on the house or his
writing. Then a "sick day" occurs and without warning
or explanation she writes:

Friday, February 11, 1887

Busy making cake but feeling very badly and
gone out altogether just before lunch.

No one over during the day except Lillian Frow
who brought a bouquet of flowers.

Saturday, February 12, 1887

. . . I am busy all day. Rev. and Mrs. Brown
called just at dinner cooking time. I did not see
them. After dinner Kirk and I went over to P.O.
and spent the evening. Cooked beef stew, maca-
roni, beets and hominey, pudding for dinner.

I am all fed up!

Nothing in the journal suggests what that last com-
ment referred to. It may have been work overload; Mary
baked bread nearly every day and the rest of her house-
work was certainly labor intensive and time consuming,
so when something went well she made a point of
writing it down as on February 23 when she notes, "I
succeed with the blanc mange today."

But again at the beginning of March something

destroys her equanimity and shows that neither the difficulties of running a household nor the social life she had with other residents and visitors in Coconut Grove was enough to distract her from her need for her husband's approval.

Saturday, March 5, 1887

The mail came early. Charlie went after the letters . . . I made myself very unhappy about one that Kirk would not let me see . . . Of course, I know that it is nothing but I can not bear that he will not trust me and yet I do not blame him. I am such a . . . [This last sentence is crossed out.]

In the afternoon Mrs. Hines came over with Miss McFarlane and in the evening we all went over to the Post Office to have some of Alfred's birthday cake and we had a very pleasant time.

Oh my dear handsome husband. My dear dear Munroe.

Again, Mary's journal is tantalizingly unclear about what caused this momentary shakiness in her self-confidence or what smoothed it over but the importance to her of Kirk's happiness shows through in small ways. When he praises her cookies, for example, the compliment is duly noted, or when a boat arrives bringing their groceries from Key West and New England, she writes, "We were so glad over Kirk's cigars that we had a few of them after dinner."

For the most part, Mary's journal for 1887 is filled with minute details about daily life: about getting exactly two eggs and a loaf of bread from Mrs. Frow, about how she likes her new stove, and how the front porch is nearly complete and Kirk has built some more closets and shelves.

Mary never directly complained about her daily work, nor did she ever repeat her early 1886 wishes to leave Coconut Grove. But she does begin towards the end of 1887 to write about how uncomfortable the heat and mosquitoes make her feel. The entries also show Kirk's solicitude toward her.

Tuesday, April 19, 1887

I not well all day. It was very warm in the evening so had a cold bath and we pulled the bed down in to the breeze. 94 degrees in the shade all afternoon and a 106 degrees in the sun . . .

Thursday, April 28, 1887

A pretty uncomfortable morning with heat and mosquitoes. We sat on the wharf for a while after breakfast . . . Then Kirk trying to write and I doing some washing. About noon I have a real fainting spell but after a rest felt better and walked over to PO . . . The mosquitoes so bad that we both went to bed to read our mail.

Friday, April 29, 1887

We spent the day as best we could but it was so hot and the insects were so bad. I had an uncomfortable time about noon with the heat but Kirk would not let me do a thing after lunch so I had a rest . . . Kirk took [us all] for a sail in the "Allapatha" . . . to get cool. The dinner was pretty uncomfortable—the mosquitoes were so bad I went to bed right after dinner and Kirk soon followed. William had to build a smudge for us to eat dinner . . .

Saturday, April 30, 1887

94 degrees. Very warm. The mosquitoes very bad and I very warm. After breakfast I did as little work as I could get along with and after lunch I did nothing but washed my hair and dressed as cool as I could. Kirk fretted about me all day . . .

Kirk took me out for a sail before dinner and afterwards we went for a moonlight sail. It was such a relief after this day of heat and mosquitoes.

Like the year before, Mary's third season in Coconut Grove in 1888 was full of cooking, cleaning, washing and sewing. Added to this, there are frequent food

exchanges between neighbors of eggs, game, produce or cooked foods. This community gift-giving was one way of cementing social networks, but for Mary keeping track of all she did or produced on a daily basis seems also to be a point of pride, whether it was frugally recycling her old clothes or sewing mosquito netting.

During this stay of nearly four months, she was unexplainably ill almost a fourth of the time. One possible cause for the fragility of Mary's health might have been the fashion of "tight lacing" corsets in the 1880s and 1890s so women could achieve the preferred ideal of an eighteen-inch waist. While there is no evidence that Mary was a slave to fashion, her journal does note her ordering corsets, and it's conceivable that she, like other women of her time, suffered from what some fashion historians have called a "portable prison of tight corsets and long skirts" where breathing became constricted and movement was restricted.

However, even when she was feeling her best, things didn't always run smoothly.

Sunday, January 15, 1888

Busy all morning putting up pictures and covering shelves. Young Trapp called and just before lunch Bertha and Albert came in. *I was having one of my times and so hid there . . . could not talk to her . . .*

Mrs. Pent sent me a nice little turtle.

Monday, January 16, 1888

A lovely day. I went over to the PO after breakfast. Took the aprons for Mrs. Peacock and got six eggs, some tomatoes, and a pineapple. When I got back, put the turtle in to cook but it was not good. I had forgotten how to cook it.

Tuesday, January 17, 1888

I busy with the house and Kirk with his boat . . . I cleaned the kitchen all but the floor. We had the turtle soup over again but still it was not good. I failed some where but Lillian Frow brought over a loaf of bread from her mother.

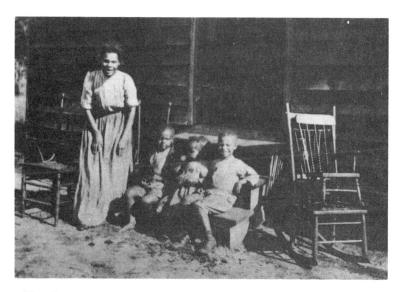

Mrs. Stirrup, in 1898. From the beginning, Coconut Grove had a black Bahamian community. Kate Stirrup Dean recalled in an oral interview that Mary B. Munroe had read her her first nursery tales and sent over food and medicine when her mother was ill.

Wednesday, January 18, 1888

A hard sick day. Nothing seemed to go right. Tried to have light biscuits for breakfast and failed and had breakfast very late. Then tried to cook some cake. It did turn out good but it was hard working all day—A late dinner . . . and both of us went to bed early tired out.

But Mary had more good days than the year before, and her diary is filled with happy memories.

Wednesday, February 1, 1888

Munroe got up first this morning to make cake for breakfast and they were good. After breakfast I finished my sewing . . . Munroe so good and kind and patient with me . . . [He] sat with me while I made dinner.

Tuesday, February 7, 1888

Kirk began his California story after breakfast and lunch. A picture [does] he make [as I] look in his study door before going in. I watched him

from the kitchen. He has written the introduction and it is good.

Tuesday, April 17, 1888

A splendid day. I did all the washing and had it out before lunch. Then I did the ironing after lunch. Feeling very well all day. Munroe hard at work on S.D. [Soldier Days]

Sunday, April 29, 1888

21 years ago today my boy left home to make his own living to go out west. [Kirk left his Cambridge, Massachusetts home in 1866, at age 16, to work his way west with a surveying group. Before returning to Harvard University, his adventures took him to Oregon, California and to South America; Mary made note of this anniversary every year.]

Today he is writing "Soldier Days of 49" in his new home. It is a lovely day. We picked the first Jesmin [sic jasmine] flower and put it on his writing table . . .

Mary's contentment and self-assurance grew over the winters of 1889 and 1890 when the Munroes returned for nearly six months with two young boys, Howard and Marsh, who were related to Kirk's publishers. Despite being responsible for a larger household now, Mary writes less about housework and more about social institutions such as the Sunday School and the Biscayne Bay Yacht Club. There are lots of sailing races on the bay, and Mary makes less note of the heat, the mosquitoes, and illness.

Yet Coconut Grove was still a relatively remote community. One visitor from Lake Worth, Emma Gilpin, who sailed there in April 1890, noted in her journal, "stop to see Mrs. Peacock's new baby—a grandchild born on Easter Sunday—a week old today. What a life of isolation and self-dependence."

Oddly, Mary's journal makes no special note of the birth on Easter Sunday, April 6, other than to jot down the next day that there was a new baby boy at Charles James Peacock's house. It can't be determined whether this was caused by her own sensitivity to being childless or not. Still, it seems curious, considering the small size of the community, the fact that no doctor attended the delivery, and the risks to mother and to child during childbirth.

The Munroes' growing attachments to Coconut Grove drew them back again in December 1890 to celebrate Christmas with their friends. The new year of 1891 was notable in Mary's journal for many reasons: for the first time she talks about community dances, and she also refers to getting help with the washing and ironing, perhaps either a sign of her growing weariness with the heat and hard work or a necessity caused by her growing community involvements. She was not only active in the "Housekeeper's Club"—a sewing circle/fundraising organization for the Grove's matrons, founded by Flora McFarlane—but she began a junior version of it, the "Pine Needles" for girls. Also, in 1891 she suffered an extended "sick" spell right before Kirk leaves for a Key West cruise.

Thursday, December 25, 1890— Christmas Day
There have been twenty-two people here. Charlie brought a leg of venison and gave Kirk a third . . . For dinner roast chicken, tomatoes, market potatoes, peas, pudding, mince pie, coffee, nuts, raisins and fruit cakes, cheese and pickled peaches . . . Gave children paper and crayons [?], costumes, bon bons, and cakes
Sunday, January 18, 1891
A pleasant day. Up late and took my time about every thing. In the afternoon I went over to see Mrs. Aubury about getting her girl to come and

do washing. Got her to promise to come. Then in the evening I went over to the PO and spent the evening with them all in the big sitting room.

Friday, February 6, 1891

Kirk cut the first and only orange on the tree. He will eat it Sunday. Dick [Carney] came over [to see] if they could have the boat house for a dance as Uncle Johnny was here to play for them. I went over to PO to see about cake and went out to the coontie mill and saw Albert and George hard at work making starch.

Kirk decorated the boat house with flags and waxed the floor. As far as I could count there were over fifty people there. I took care of Mrs. Mollie's baby while she danced. Kirk had some good dances and did not get home until after midnight. I came home about ten. They had limeade for refreshments and corn water . . . Some brought blankets on which to put the babies when they went to sleep.

Thursday, February 19, 1891

Writing letters for the mail boat but it did not come. Then in the afternoon I went over to School House to meet the women by request of Miss McFarlane. There were Mrs. Frow, Mrs. Newbold, Bertha, Miss McFarlane and myself. They elected me President but I do not think I shall stay.

Friday, February 20, 1891

Busy all morning cleaning the house and making bread in the afternoon . . . After dinner we went down to the boat house for a dance. Mrs. Bentwood played the organ for us to dance by . . . We had a real pleasant time and I had my first dance in nearly a long day— seventeen years [crossed out] nineteen or twenty years! I believe— with Mr. Hines.

Thursday, February 26, 1891

After lunch went to the 2 [second] meeting of

"The Housekeepers Club" only Miss McFarlane and myself present. [The club would grow from six to 29 members that first year. Of the original members, only Miss McFarlane was single. Because of missing census records, it's impossible to know if any other women besides Mary were also childless, so it's interesting to wonder whether family responsibilities kept the other members home from this second meeting.]

Saturday, February 28, 1891

I busy baking bread and cake for Kirk's trip to Key West. [Kirk had promised to take a visitor, Mr. Hodge of Washington, D.C. sailing to Key West.] . . . I so ill I spent most of the day in bed and Kirk had to ask Mr. Hodge when he did come to go to the Hotel . . . I think I have the grippe . . . Kirk quite uncertain if he can leave me but . . . I feel sure there is nothing serious about my trouble. Dr. Phillips thought I had taken too much quinine and was poisoned but I think it is the grippe. Kirk busy all day looking after me and the boat and the place.

Until this point in her journal, there is no mention of quinine, malaria, or Mary dosing herself with any regular medicine. Nor were daily doses of quinine common in 1890, so we can't tell why Mary was taking it. However, it may have had something to do with the climate or the mosquitoes. At any rate, Kirk did leave for Key West the next day, and Mary recovered and resumed her social activities.

Wednesday, May 20, 1891

Kirk suggested that I should start a girls club so I talked it over and decided to do it on Mama's birthday.

Tuesday, May 26, 1891

We had dinner at the Hotel and a good dinner. Mama's 70th Birthday. I made cakes this morning for the "Pine Needles" and one for ourselves. The club was formed of nine girls . . . We start to

make sewing aprons out of bed handkerchiefs. Kirk came in just as we were eating the cake and we adopted him as "Father Needle."
Tuesday, June 2, 1891
Busy all morning sewing and arranging the house. Sixteen Pine Needles met in the afternoon and we did our good work ... We had limeade and ginger nuts for refreshments at the Pine Needles. I went to the PO after the club had broken up and had a talk with Mrs. P[eacock] and Miss McF. about the coming tea.

Teas, club meetings, sending food and medicine to sick neighbors, helping to organize a community library, and doing "good works" would increasingly fill up Mary's life and the pages of her journal. In 1909, Mary wrote about pioneer women for the *Miami Metropolis*. The identity of this early housekeeper is never revealed in the article, nor does it appear in a careful search of Mary's journals. Perhaps Mary was really talking about herself:

I wonder how many women in Dade County today would have come here of their own will ... I know one woman who wore a sun bonnet all day both in and out of the house for the first month she was at Coconut Grove so that her husband should not see her crying. Today she is very happy in the home he gave her as we all are after a few months of "settling down," but it is hard for a man to realize what it means to a woman to give up family, friends, church, doctor, and a comfortable house ...

They do not realize the fear the women have at finding out that crawling creatures of the earth are so near to them, or the pain that comes with the hardening of soft hands in doing the daily housework . . . and the women will seldom let them know. So the men are not to blame ...

Pioneer life, as we know, is always hardest on a woman, but one of the wonderful things about

it is a woman's ever willingness to follow the man of her choice. Old or young, the wilderness has no terrors for her like being left behind or having Him go alone.

The Early 1890s

John and Emma Gilpin and their sixteen-year-old son, Vincent, came to Palm Beach as tourists in 1890, after exploring Florida's west coast on earlier trips. Living in West Chester, Pennsylvania where John was a semi-retired commodities broker, the Gilpins enjoyed a hearty outdoor life during long vacations. They were constantly off fishing and sailing—to Florida in the winter and the Adirondacks in the summer when they weren't touring other parts of America.

Since the 1870s, healthy, upper-middle-class Victorians had been coming to northern Florida for the fishing, sailing, and semi-tropical scenery while consumptives and other sufferers came for the sun and mild winters. By the late 1880s, branch trains running south of Jacksonville and river boats had opened up areas along the Indian River and further south, so tourists followed pioneer settlers. By 1884, Ella and E.N. "Cap" Dimick, who had arrived with the Geers in Palm Beach in 1876, had opened the area's first hotel, the Cocoanut Grove House.

Other small hotels and boarding houses on Lake Worth were also taking in winter guests by 1890, and wealthy northerners were starting to build winter cottages on Palm Beach. R. R. McCormick, a Denver industrialist, had bought Marion Geer's homesite in 1886 for the munificent sum of ten thousand dollars. The Geers returned north because of their children's

education, but their Dimick in-laws stayed on. Anna Bonker and Fanny Brown had also moved away by this time, but Margretta Pierce's family was still on Hypoluxo Island. Stopping off there on a sail to Lake Worth's southern end in 1890, Emma Gilpin noted that they grew vegetables and fruits. "Nice place if well kept up" is her description of their house.

Emma Gilpin's journals and letters show Palm Beach changing from an out-of-the-way destination for adventuresome tourists to a winter Newport for high society. The Gilpins came for about three months each year, and the tone of the letters is chatty, full of social news about the winter guests and "cottagers." They evoke a period of uncomplicated amusements: sailing, amateur musicales, whist or euchre parties, and outings.

Emma is also a "naturalist," possibly as a result of growing up in rural Lancaster County, Pennsylvania as a millwright's daughter. She takes a keen interest in the tropical plants around her, jotting down their names in her journal in much the same way a birdwatcher today records all the species sighted. She samples exotic fruits—papayas, sapadillos, and alligator pears [avocados]; hunts for driftwood, seashells, bird's eggs; packs air plants to send home; and skins birds that her son shoots. Above all, it's Emma's enthusiasms that make her writing so lively. In it, we see not only what early Palm Beach social seasons were like, but also how active a Victorian matron (she was born in 1846) could be.

The Gilpins first discovered Lake Worth in 1890 when an Indian River steamer captain suggested it might be worth a visit. Because their stop was really a last-minute impulse, they stayed only about six weeks, and much of the time was spent on a sailing cruise to Biscayne Bay. It was the combination of sailing, good companions, a mild climate, and exotic nature that captured the Gilpins and kept them coming back.

"Everything looks so promising we think we will stay

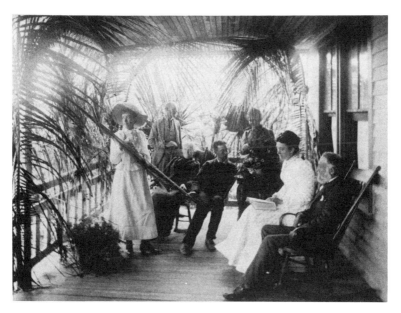

*Emma and husband John Gilpin, seated on the far right, with son
Vincent seated in the center on the porch of the Cocoanut Grove
House in Palm Beach, in 1893.*

here awhile," Emma wrote on March 19, 1890, the day
after checking into the Cocoanut Grove House. "There
are plenty of boats for *free* use of guests—there is sea
bathing—there are ducks, birds and *deer* in the ever-
glades which are just beyond the ridge on the opposite
side of the lake . . . Over the grounds are some of the
most curious and rare (to us) trees—the Royal Poin-
cian, the rubber (growing like a banyan), sapadillos in
fruit, avocado pears in blossom, sugar apples, sour
sops, pineapples, etc. We tried cocoanuts in all stages
of advancement—drank the pleasant milk and ate the
custard for the first time . . ."

On and off the hotel grounds, Emma met other
comfortable, upper-middle-class families, and much
time was spent in social networking and determining
who was related to whom. Mr. Joseph Mulford, the first
minister of Bethesda-by-the-Sea, the Episcopal
Church, and his wife had brought their nephew

Sanford to Lake Worth for his health. Son of a prominent Troy, N.Y. family, Sanford Cluett would grow up to develop "Sanforized dry cleaning." He and the Gilpin's son Vincent were companions, and through the boys the families also became friends.

Saturday, March 22, 1890

Warm—80°. V. [Vincent] and a lad Sanford Cluett go out fishing in the morning and ducking after dinner. I get my sewing box and do a little sewing in the morning. It is so delightful to rest that we do not go out in the sun at all. At tea time, Vincent returns and reports the capture of six ducks . . . They come back in the best spirits and with strong determination to try it again . . . Sanford is nearly as old as Vincent but quite a small boy . . . is a nicely trained lad and very sweet in his manners and disposition. Mild tempered and promptly obedient—a far more suitable companion for V. than I could have found had I hunted.

Sunday, March 23, 1890

J. goes over to the Beach before breakfast and takes his sea-bath. Comes back enthusiastic over the freshness of everything—plants and birds... Many pleasant people among the guests.

Monday, March 24, 1890

We went to the store. Found straw hats and flannel shirts and a beautiful white heron plume which I bought—also an Indian buckskin which I bought for some little moccasins. The supplies in the store are good and seem to comprise all necessities and many things we did not expect to see here as ammunition, leggings, etc . . .

After dinner Cap Dimick finds us a door frame and netting for our doors against the flies and mosquitoes. I help to get them up . . .

Tuesday, March 25, 1890

Rise in time to go to the beach before breakfast. J. takes a dip. I take a wade and find the salt

sea water takes the sand heat soreness out of my feet very quickly. Return gathering flowers all the way, to breakfast at eight.

Friday, March 28, 1890

Called on Mr. and Mrs. Reynolds [who] gave us a drink of their cistern water which has a brick filter built in it. It was colorless and good. They heat and cook with kerosene, and Mr. Barton expects to heat, light, and cook with gasoline as does Mr. McCormick, his neighbor.

Saturday, March 29, 1890

As we went over [to the beach] on the Palm Avenue we meet the long brown snake which the Professor [Mr. Kinzell, a guest and naturalist] took there this morning. So tame it stopped in our path evidently waiting to be picked up. It moved away at last when I urged it a little with my skirts.

Sunday, March 30, 1890

Mr. Mulford will have services at eleven A.M. and Mr. Barton's boat will be at the service of the guests who want to go . . . [Later, we] go over to Mc Cormicks and look about with much interest . . . We find [the house] very attractive with marble floors, hard wood finish—Honduras mahogany, Spanish cedar, yellow pine, etc. and papered by Chapman of Philadelphia. Our library frieze is on this parlour . . .

Thursday, April 3, 1890

Invited . . . for a sail to the Inlet . . . to see the high surf over the *rocky coast*—a limestone rock washed into holes and basins by the ceaseless actions of the waves. [Probably near the present Blowing Rocks Nature Preserve on Jupiter Island.] The wildest sea picture we have seen for a long time. Air delicious. Back of us the high sand bluff is blooming with saw palmettos and permeated with the strong and delicious fragrance . . .

Back to boat for lunch, then a wade around after conch shells and sea snail spawn. Another walk to look at the sea horses dashing over the rocks and weigh anchor for home.

Despite excursions to the beach and sailing, Emma doesn't mention going swimming and sea-bathing until the following year, possibly because in packing for northern Florida she forgot to bring a suitable bathing costume. What's remarkable, however, is that rather than sedately staying close to the hotel or sitting on the veranda in the evening, Emma, who was in her forties, and John, in his sixties, were out and active both day and night. Part of Emma's adventuresome spirit carried over to her son Vincent whom she allowed some potentially risky pursuits.

Monday, April 7, 1890

Vincent and Sanford are preparing for a *panther* hunt tonight hoping to gain the consent of the Mulfords and ourselves to go on the expedition. Consult after dinner and after insisting on several cautions we consent to let them try it to their great delight.

After dinner [they] get a lunch and start with guns and wraps at three A.M.—in the Exile [the hotel's sailboat].

We look and feel a little dubious over the results but appreciate their animal spirits over the affair and feel that the man living on [illegible] will help them out if necessary. So start off with nails and boards, singing "good bye ladies."

The night is windless and cloudless with a clear bright moon. Just right for the boys. Hope no harm will befall them. Go to bed at two A.M. No sounds or sights of them so far.

Tuesday, April 8, 1890

Boys in at four A.M. Made their perch on a tree about six feet from the ground and started their wait. The mosquitoes visited them in vicious clouds and made their stay nearly intolerable.

They could not avoid making a noise, wriggling about and killing mosquitoes . . .

At last the moon rose and they could see better and settling on their cramped "gridiron" perch as comfortably as possible, weariness at last conquered even the mosquitoes and the hunters fell asleep to be wakened to the consciousness of their lost opportunities. A search verified their worst fear—the panther had come and gone! There were his *fresh tracks* about the fresh water pool.

As they were forbidden to sleep in the boat they came sailing up the lake between three and four A.M. and getting thoroughly roused had a little fun at the wharf. Wind died out [so] V. rowed and towed the Exile while S. steered for fun. He steered the wrong way and tangled about a little sharpie of Mr. [Ralph] Munroe of Biscayne Bay, when suddenly a head appeared and a voice called out, "What are you trying to do?"

The hilarity was brought to a sudden conclusion and the boats were properly anchored and the last contents of the lunch pail demolished after which the boys crept silently to bed. I heard Vincent when he shut the screen door and rose to see that they were all right. He slept till ten— ate breakfast in his room while Mrs. Mulford and I laughed over their experience, happy they were in and safe . . .

Within two days, the Gilpins began a family adventure of a different sort as they set sail for Biscayne Bay in the Heron, captained by George and Ben Potter. While sailing cruises weren't necessarily dangerous, they could be unpredictable. This three-week trip in a small, forty-foot sharpie sailboat took them through stormy seas and left them marooned at New River, near the present Ft. Lauderdale, waiting for good weather and tides.

Emma faced the rough sailing with equanimity:
> Kingfish and coffee made a palatable breakfast
> but alas! a choppy sea would not permit us to
> enjoy their benefits and while I was bracing
> myself in my cabin to write a letter I felt my time
> had come and I went quickly on deck to get a
> comfortable relief there. V. was in the "same
> boat" at the other end of it.

And after she falls into shallow water while she's in
the middle of skinning and curing a bird—"evidently a
fish bird [since it] smells very strong and is very full of
green fat"—she's more concerned about practicalities
than her dignity:
> I found myself losing my balance and to my
> horror going over into the water. Mr. Potter
> grasped one hand and with the other I grasped
> one of the halyards which always holds me when
> we are sailing, but unfortunately it gave way and
> Mr. P. could not hold my weight so down I sat—
> back first into the water . . . I struggled to my
> feet—mouth full of salt water and strangled
> breath gasping and choking but on my feet . . .
> My first thought was of my watch and I handed
> it to Mr. Dewey [the tax collector who accompa-
> nied them] to wipe off for me. I went down to
> change everything . . . to wash out each garment
> [and] hang them all up in this high wind to dry—
> a process soon accomplished to my surprise
> with none of the usual salt water stickiness.

The Gilpins returned to Lake Worth in 1891 using
the route followed by most tourists before Henry
Flagler's Florida East Coast Railroad reached it in
1894: ocean steamer or train to Jacksonville, spur rail
or steamer for a trip up the St. John's River to Enter-
prise, another train to Titusville, another steamer
down the Indian River to Jupiter, a narrow-gauge train,
the "Celestial Railroad," for eight miles to Juno, and

then a final steamer to the hotel.

Emma's letters home to her sister-in-law Susan Gilpin Hazard this year talk less about the natural aspects of the Lake and more about the social life.

On the sleeping car between Savannah and Jacksonville
Tuesday morning, February 24, 1891

Vincent's fears that we might have a swell party for neighbors that would be shocked at our plebian lunch basket were entirely groundless— Our neighbors who seem to be going down the Indian River, possibly to Lake Worth, are loaded with a most elaborate home lunch, put up in immense big boxes—deviled crabs on the shell, pickle bottles, whole rolls, white grapes, etc. Our good basket looks quite modest—so we live by comparisons . . .

Titusville on the Indian River
Wednesday morning, February 25, 1891

We got here last night in time for supper and a long night's rest in a quiet bed.

At once, reports of the crowded condition of . . . Lake Worth poured in upon us. They say Mr. Dimick sent out notices last week that none need apply as he could not accommodate another one! Encouraging—and then the boats down the river were full—all berths engaged long ahead! We concluded we would telegraph to Dimicks and found at the office that a terrific wind storm last week blew down the wires and they have not yet mended all the breaks of 150 miles of wire . . .

It certainly is a full season. They say at Rockledge [a resort along the Indian River] the guests are sleeping on tables and floors and even in the little boats in the bay.

Despite the crowding and their lack of advance reservations, the Gilpins were able to secure rooms at the Cocoanut Grove House. "The house is full, full but

changing constantly ... They are doing a good business with transients at three dollars a day," she writes on March 2, 1891. A "cordial welcome" from last year's friends renews her enthusiasm.

Wednesday morning, March 4, 1891

What a place for babies to grow out of doors ... Temp. this morning is 70—John went over, before breakfast, to take a sea-bath and returned much refreshed ... the bathing hour is 11 A.M. when the ladies and others go together. Of course, I forgot my oil silk cap and cannot go in till I find a substitute. My hair would never dry. [Interviews with her grandchildren revealed that Emma was very proud of her long, thick hair and that may be why she was reluctant to get it wet.]

Yesterday the young girls had an "afternoon chocolate" on a neighboring piazza, where we met for a merry chat. There are sailing parties, whist, and euchre parties, musicales, etc. and the young people do certainly have a happy time ... V. passes for a boy of nineteen and is in great demand.

Sunday night, March 15, 1891

Do continue to mention the temperature and condition of the weather when you write. It seems more real when you tell us that it is wintry, than when we look back among the old newspapers and learn from them. We can scarcely imagine a wintry aspect amid our ... full vegetable gardens and fruit trees ...

I have just come in from Evening Service, held in the Parlour, which half of us heard from the Piazza through open windows. Only such a north gale as we had yesterday ever persuades us to *think* of closing our windows day or night ... Even when the days seems warm on the lake side, a fresh breeze is afloat on the ocean side rattling through the stiff leaves of the palms ...

We have ripe tomatoes every day and the new potatoes, waxbeans, peas, etc. They ship tomatoes North . . . but they are very green when packed here and when eaten North can bear no resemblance to the same fruits eaten here . . .

Friday, March 20, 1891

Tuesday night Mrs. Mulford had a musicale and we had a lovely sail up in the moonlight on a commodious launch with sails and a naphtha engine . . . the rowing and sailing by the light of the moon proves to be almost irresistible and the young people are constantly scudding about at night. Never were moonlights more appreciated and enjoyed . . .

The guests are so pleasant and everybody is so happy . . . Purchasing is going on about the Lake and the residents feel that the future of the place is quite assured. It certainly is . . .

Good Friday, March 27, 1891

The young people make the most of the moonlight, you may be sure, and the old ones too for John and I... are among them on their moonlight frolics. Remember we live *out* of doors . . .

Monday morning, March 30, 1891

The moon-rise has sent parties out to the beach on Good Friday night where the scene was supreme. Can you picture us *sitting on the sands* watching it for an hour or more!

Saturday night we saw it rise from the Cupola of the house, and often when I rouse before sunrise I slip up to the house top before getting dressed for the day in slippers and wrapper to see the moon set in the west—the sun rise out of the sea in the east and Jupiter Lighthouse blink at them both from the North while the waking birds chirp and twitter below me in the tops of the coconut trees . . .

Saturday brought us your letters and the box containing the silk oil-cloth and rubber cord. . .

I am much indebted for the thought—will use it at once. [These are the materials Emma needed for a bathing cap.] I succeeded in making one of light oil cloth but it was heavy and this cloth will be pleasanter. We do not like to miss the sea dip a single day.

Despite what she told Sue, her sister-in-law, Emma's private journal for March 31, 1891, suggests that swimming and sea-bathing were not always easy for ladies:

Breakers rolling in finely—no undertow. Mrs. Worthington [another winter guest] and I go out bravely with hold of Vincent. Get used to having the waves break over our heads. After a long battle with them, she and I start in. Walk along to get sand out of our dresses. An unexpectedly big wave overtakes us—knocked me down with my knee twisted under me. I knock Mrs. W. down. She rolls over and over. I rise soon but find my knee is sprained and I cannot use my foot—hold on to Mrs. W,. who struggles but cannot rise—being washed ashore all the time. Make a desperate effort and drag her to her feet, gasping-strangling. I cannot walk. Those on the sands come to help us. [I get] to the bath house and I manage to get dressed and Mrs. W. manages to get her breath and dress too. My left thumb joint is sprained and the ligaments on the outside of the left knee have been twisted... John helps me up the rises [steps] and I get in— bathe with hot water and amica and hope it will not be serious. Mrs. W. bruised all over with her rolling about and feels as if she had swallowed the whole sea.

Still, in the interests of impressing Sue with what a wonderful vacation spot Palm Beach is, Emma makes light of the accident.

Sunday, April 14, 1891

The breakers knocked me over last week and

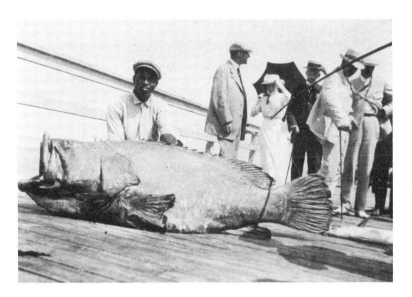

High society at Palm Beach: Catching a large jewfish on the Breakers' pier.

I twisted one knee which curtails my ocean gymnastics just now, tho' I get the full benefit of the salt water without diving through the breakers. I let them come to me.

In 1892, the Gilpins spent their first two weeks in Florida showing the area's sights to Willis Hazard, John's brother-in-law and the husband of Sue to whom most of Emma's letters were addressed. This year Emma writes about the rumors of a coming real estate boom. It is probable Willis had come to Florida to invest in real estate, and Emma's interest in land speculation belies the myth about married Victorian women having no interest in "public spheres" outside the home. In describing the potential for turning one early settler's homestead into a hotel, she writes, "A little money would go a long way there." Perhaps because of the new business interests in the area, the social pace seems to pick up also.

Friday, March 4, 1892 10:30 P.M.

[Tuesday] we went sailing by moonlight with a fine phosphorescent display into Lanehart's Bay, behind the Island, stirring up the schools of fish in the shallows. The ladies stood on the bow of the boat where they could see every line of the mysterious light while a trailing hand in the water produced a pathway of starry illumination . . .

Wednesday morning we spent in my room with the boys and Nancy [Kimberly, whose family was connected to the Wisconsin paper company, Kimberly Clarke]. Had a sewing bee while V. read to us. [Later] the boys went on a duck expedition to the pinewoods. After a good evening of Blind Man's Bluff in the parlour, we were ready for a good sleep.

Thursday V. and Sanford started for the Parkin's Lake to spend the day and I was glad to have my first uninterrupted morning in my room to reduce the confusion which was there . . .

Jessie Cluett and Mr. and Mrs. Robert gave a lovely musicale in the parlour last night—voice, piano and violin . . . our days are so full [that] letter writing is almost a forgotten art.

Tuesday, March 15, 1892

Tell Willis that all sorts of things of interest to him are going on, all sorts of real estate speculations talked of.

We cannot lay our hands on George Potter—he is off in the Everglades somewhere surveying some county lines. Of course, the "Heron" [Potter's sailboat, which the Gilpins often borrowed] is with him to our disgust as we hoped to have her to use . . . Mr. Dewey has been off to Jax—St. Augustine—and Tallahassee on *land* business and says he has been profitably successful and there are all sorts of rumors in the air . . .

What a pity Elizabeth and Edward [some relatives] are not here—it *would do them both good* and the girls would have such a good time. There are so many nice young people here. Vincent and Sanford are happy as the day is long—were out all last night to hunt *wild cats* but they did not get a shot. We will have wild ducks for dinner today that they brought in last evening . . .

Wednesday, March 16, 1892

Want to ask you to get a bottle of homeopathic pellets and send it by mail very soon. The mumps seem to be epidemic here—a child brought them and they are running through the house. Vincent has never had them—neither have I . . . One of the young men in the house took cold on [account] of them and was very seriously ill for several days. I know we can not run away from them now, having been exposed so long, so I thought I would be better prepared, if you would get the medicine bottle for me, and any hint on mumps. Perhaps if I prepare for them, they will not come at all . . .

Monday, 5 A.M., March 21, 1892

We have had a sad time here. On last Monday a party of Philadelphians registering as Pauls and Masters started from Rockledge. Mrs. Masters was unwell at Rockledge and was sick enough to go to bed as soon as she got here on Tuesday morning. Mr. Masters was ill with grip at home and soon as he was able to go out they brought him to Florida . . . Doubtless the wife was reduced in strength by nursing, perhaps, and her first outing was an exposure. She took cold and she was threatened with pneumonia. She did not call Dr. Potter until Thursday when he felt her case nearly helpless as it was complicated by a weak heart.

They have with them a sweet young daughter about twenty—she and her father waited on the

mother till Friday night when he was nearly if not quite sick and she was worn out. No nurse could be found and Mrs. Kimberly found out their needs and asked me to help her that night. The ladies were very thoughtful and changed about day and night. I have been up all night for the past three nights but the most careful nursing was of no avail and last night she died. The Doctor stood over her day and night but without any hope. Imagine that heart-broken husband and daughter! She died about eleven P.M. and this morning all is ready for their sad journey homeward. It is the first death that has ever occurred in this house. Everyone feels it though the little lady was not down once since her arrival. I write while I wait for the boat . . . I want to see them off. It is so sad . . .

Wednesday night, March 23, 1892

Dear Willis,

We had a jolly time last evening—to break the gloom which has fallen over the house after the death of Mrs. Masters on Sunday night. Sanford had a plan with Vincent and Nancy to spring a little joke on Mrs. Kimberly. He put on a dress of Nancy's (just her height and size) and paraded around with Vincent, deceiving not only Mrs. K. but everyone else—the trick was such a complete success that everyone in the house was convulsed with laughter as the solution dawned upon one after the other . . .

[A later note written by the grown-up Vincent explains that Mrs. Kimberly had been sent to the dock to investigate what her daughter Nancy was doing. Nancy remained on board a catboat while Vincent and Sanford, dressed as Nancy, emerged from the cabin with Vincent's arm soliticiously wrapped around "Nancy's" waist, behavior which was apparently scandalous in days when young people acted with great discretion.]

Mr. Reynolds *has sold* his place to a Mr. Charles Clarke of Pittsburgh—a millionaire, *they say,* and already he has ordered a sea wall constructed—the house enlarged for his family of three daughters and two sons. A fleet of boats, which he owns, is to be brought down, etc. etc.

He is a Congregationalist and has contributed to their Church Fund already. The members are elated and feel stiffened in hope of a church building. Pity that *one* church building could not serve this little community but many men of many minds.

The Bartons are delighted with the purchase of the Reynolds place because they hope for fine improvements and expenditures that Mr. R. could not afford. I think it is a good place to own a house—near the Hotel and next to a pretty private place. Mrs. Kimberly and her mother [went to Hypoluxo to look at some beachfront property] and wanted to buy a lot at once. Field wants $500 for a 100-foot front . . . I teased him about the *100 foot lots* in the sandy deserts of Florida—told him I should want at least five such fronts for each house. Absurd hundred foot lots!—but suppose it will suit some people. Less to care for . . .

John talked to Geo. Potter about his place [Figulus, located on the south end of Palm Beach]; Potter willing to come down from $6500 to $5750 but wanted $550 for the boat—the last $50 tacked onto his first asking price because he had just put in a new mast . . . J. offered $5000 for the place and $400 for the boat and there the matter ended . . .

Afterward we learned that the steamboat [which traveled down the lake carrying passengers and tourists] can not now get in to their dock and there is no channel south from there without coming up and around the islands—a

long round. They say a channel could be dredged but it would fill up constantly. You see that would not do for a woman's hotel . . .

We were glad Geo. Potter did not consider John's first proposition when we learned the disadvantages. Capital and perseverance will conquer these difficulties but J. does not want to invest either to any *great* extent, neither do you, I imagine. So it is all off and we are not sorry. For a boarding house, I am absolutely sure Figulus would not answer. We have learned a good deal about water and land since you were here . . . I tell you there are always *cons* as well as *pros*. . .

We are quite giddy down here. Mr. Cragin invited us on a moonlight sail on his fine boat. Mrs. Robert had a lovely tea on Tuesday for the ladies . . . Saturday Mrs. Barton entertains us all at four o'clock tea. The Lawn Social last Tuesday—and in the midst of all, eight days and nights of sorrow and death . . .

A week later, Emma is still concerned enough about the failed Potter deal to write to Willis:

Wednesday, March 30, 1892

We fear you are disappointed about the Potter place but we would make no offer for it, in your name, till you had learned all the disadvantages. Capital will overcome all of these but the question is do *we* want to invest the necessary capital.

Captain Dimick is going to enlarge his place this summer . . . Potter says he will not offer [his property] at this price next year . . . The West Side [of the lake] *is* fine and will assuredly come in the future—as a piney woods sanitarium nothing could be better . . . A hotel on that side must come soon.

Thursday morning, 6:30 A.M. April 7, 1892

Dear Willis,

Mrs. Kimberly is a real Lake Worth enthusiast

and she is determined to secure a place before she returns to the North. She fears all the places will be bought up and knows that people *will* crowd down here next year . . . wants to buy from Brelsford who will not put a price on his property, or did not, until a few days ago when he announced he would not talk about any sale under *$1000 a rod front* [one rod equals fifteen-and-a-half feet].

He will hold out for it too I think, and will get it if a few more "Clarke" millionaires come along here. Mr. Clow says he [Clarke] is several times a millionaire. The nucleus of pretty houses seem to be started in *this* section . . .

Yesterday a West Side Lake front was sold at $300 an acre!

Emma's letters for 1892 continue to tell Willis about potential real estate investments. "What possibilities this place possesses . . . What a chance for a good business capitalist," she writes. The Gilpins extended their stay on Lake Worth to the end of May, long after most of the winter guests had departed, because they bought a boat and took the unconventional step of living aboard.

Thursday, April 28, 1892

You know we have our *yacht* "Heron" now. Mr. Potter was willing to sell her at the end of the season . . . She is without doubt the "Lady of the Lake," being without exception the nicest boat on these waters—trim, commodious for our purposes, small enough to use in our daily jaunts up and down the Lake and large enough to use on a cruise to Biscayne Bay as we did once before . . .

Tuesday, May 11, 1892

We are not at the above "house" at all but on board our yacht "Heron." [All of Emma's letters were written on stationery marked "Cocoanut Grove House."] Do not be alarmed—we are not

cruising on the high seas but on peaceful Lake Worth, with the steadiest winds and the brightest skies . . . A morning shower is sprinkling the lake now [but] it will serve to test the seaworthiness of our little craft.

We have the snuggest cabin you can imagine—finished in Spanish cedar—room enough for our bunks, our table, chairs, and boxes. You will become quite a sailor next winter when you are down here . . . aboard the Heron with us. All the timid ladies have been won over to be good sailors by this same staunch boat . . .

[We] left the hotel last Thursday. J., V., Sanford and I have lived aboard ever since running up and down the Lake. Stopping wherever we pleased and as long as we please and pro-visioning as we please and *cooking* as we please. I have two willing and ready cooks. I am housekeeper—Vincent is sailor—Sanford first mate. . .

We are all as hungry as sailors and enjoy our meals and sleeps.

When the Gilpins returned to Florida in 1893 with two relatives, Marie and her five-year old daughter, Mary, the real estate boom had hit Palm Beach, and Emma's letters were full of amazement at the effect it had. It was another socially busy season for her, and Henry Flagler was the talk of the town.

Sunday, March 5, 1893

The boom is on! Flagler and his railroad have made the people entirely wild and property is held sky high. Every seller has raised on last year—they say 100 per cent. Flagler has had options on *all* the desirable large properties on the lake and until his plans are decided they are not in the market. It is whispered that he closed with Dimick a few days ago. That means a *fine*

The Gilpins aboard their sailboat "The Heron" on Lake Worth, in 1893. Emma is seated on the far left; John is leaning on the cabin; Vincent is against the mast and his friend Nan Kimberley is on the far right.

hotel here next year and the property owners round about are nearly out of their minds. George Potter asked $8,000 this year without the islands . . .

Thursday, March 9, 1893

Today we read of New York "35° and raining." It was rather comfortable to read it from our perfect summer climate. We were all in sea-bathing at eleven A.M.—young and old. Marie and Mary have not yet begun. They are acclimating first. You know Marie does not like summer time, consequently she feels it very warm at times—not yet having learned to find the most comfortable corners and sides under all circumstances but the heat will not hurt her and soon she will laud the sunshine as an old enthusiast, not withstanding her long-standing prejudice. It will do her good.

Socially we have a very good time. Our old friends flock around us with warmest welcomes. The cottagers are all calling on us and little Mary is the pet of the neighborhood . . .

We now have rooms in the new house . . . We pay more than we did last year. Vincent sleeps on the boat and takes meals here. That seems to be an excellent arrangement as someone ought to be on the boat at night—we have so many things aboard that might be lifted out very easily . . .

I would like to give Willis a page on the "boom." He OUGHT to be here. Mr. Flagler, the Florida Mogul, has come at last. [He] is now on the Lake about his railroad and hotel property and everyone is in a fever of excitement. No other topic is discussed. He took options on lots of places—Dimicks, Brelsford's Point, McCormicks, and Spencers. Each one thought he would be the lucky seller and it is not yet announced so you can fancy the intense excitement that now prevails.

We have heard that it is *not* Dimicks as the agent telegraphed on Saturday that the option on this property was off. It is whispered that he has brought McCormicks and Brelsford's Point. The property holders have gone clean daft; while waiting for this decision *no property* was in the market. I think some of them will lose their senses after it is over.

Flagler goes today. Mrs. Robert, who is entertaining him, means to give him a social reception when he comes down again in April and *we* will probably meet him there . . . [She] has conquered the housekeeping difficulties bravely—has her ice chest and gets nice fresh supplies. Surprised Mr. Flagler when she entertained him last week. He thought no fresh meats could be found here. They say this winter has decided the

brilliant future of Lake Worth . . .

McFarlane asks $10,000 for his lot now. McCormicks $75,000. The West Siders ask $350 an acre ($100 last year.) The Kinzells want to sell at $5,500! The Deweys are in the market— their house is larger and prettier now and the pineapples are promising. The Lanehart's want $20,000 for their ten acre place ($10,000 last year) . . . Everyone asks for Willis. They tell me I prevented him purchasing property last year and say he might have been a millionaire now. Swift [the mayor of Chicago] has built a beautiful new house above the Clows and so has Reynolds and Roberts, Stokes, Root, and Barton and Brelsford. The place is booming.

Sunday, March 12, 1893

Flagler has been here and gone and still things are not decided and the property owners are still on the tenderhooks of suspense and expectation. He wants them to subscribe $30,000 toward the railroad and they think that is a good deal to raise . . .

Saturday, March 25, 1893

Now I am sitting on the Club House piazza at seven o'clock A.M. looking out over the lake on this lovely summer morning and I wish you were all here . . . [You] must come [here] next year when the big hotel is built. We feel now that we can tell everyone to come to this *winter Newport* . . .

I made four tick pillows of cured moss and four deck cushions of white oil-cloth [for their sailboat]. We will be quite well off and comfortable . . . Our India silk curtains are up at the Cabin windows and are a deal of comfort . . . We do have such times aboard . . . night before last we gathered the young folks and had a lovely sail. Last night all groaned for another but there was fresh paint on the cabin deck and we had to

do without . . .

Mr. and Mrs. Flagler and party come down on Tuesday and we may take them out in the moonlight. They will be entertained by Mr. and Mrs. Robert in their lovely home.

Flagler's agent Mr. Ingraham and some intimate friends—coal-oil magnates—were here last week. Mrs. Robert gave a musicale for them and we were all invited. It was lovely . . .

Oh! there is so much to tell you and there goes that breakfast-bell and my writing is done for the day . . .

I wanted to write a whole sheet to Willis on the "boom." We are so sorry he is not here in this wonderful time of excitement. No other topic is of any importance at all and the advance in prices has taken everyone by storm. I think it beats the Southern California boom and *it will last* for the wealthy people are pouring in here even now . . .

Wednesday, April 12, 1893

Our time here is getting *so short*. The weeks have flown by and we are surprised. We have been here six weeks and now they announce that the house is to be closed peremptorily, after dinner on Tuesday, the 18th.

Those who are not yet ready to go home are looking about them for some other location. The boom has knocked everything "out of sight." This hotel is to be closed so early to allow Mr. Flagler to use it for the accommodation of his army of workers. He is to have 1,000 men here during the summer—100 of them will live here—the architects, etc. For this use, Mr. Flagler is to *refurnish* the house for next winter.

The "Dellmore Place" [Moore's boarding house] was sold yesterday for $20,000. It has *six acres, not running through to the sea*, and a moderate house. That knocks that boarding house.

I am afraid that the Moores will feel so rich that they will not take boarders. The other hotels are closed and we will go aboard the Heron . . .

Flagler is looked upon as the all-powerful and expectations run high. The railroad is to be built immediately. The surveyors' tents are now on the opposite shore. The new hotel the "Royal Poinciana" is to be finished by next January . . .

Mr. Clarke who has bought Dimick's is putting on a great many improving touches and he is a first-rate fellow—an enthusiast with plenty of money . . .

I am busy from five o'clock in the morning till midnight usually. The days are very full and as the Heron and friends and expeditions are in combination every day, it takes someone to plan and carry out and that one must be myself . . .

We had the Flagler visit . . . and Mrs. Robert [had a] handsome reception for them at her pretty house. Besides the Flaglers and friends, she had a fine musicale the same evening. The whole affair was brilliant and we were all *en regle* in evening dress.

Then *our* Venetian tea on board the Heron which was decidedly the most unique entertainment given here this winter . . . Mrs. Robert told me she was so sorry I did not give that while the Flagler party was here but the weather did not suit except on Good Friday which did not suit me . . . They were here only three days.

<p style="text-align:center">***</p>

The Gilpins never wintered again on Lake Worth, not because they couldn't afford to but because they preferred the comparatively untouristy Coconut Grove. At heart, the Gilpins were sailors, and the Gilded Age of Palm Beach society that began under Flagler's influence wasn't their style. Emma's letters and journals

*Emma Gilpin
and son
Vincent, circa
1895*

written during brief visits on their way down to Coconut Grove show both nostalgia for the old days and suggest disapproval of the new.

"It feels so strange to have everyone go and to be situated in a new place. So many things are the same and so many are so different that I do not feel at all at home now," she writes on March 25, 1897. "That link is broken!" she writes about their sale of the *Heron*. "It makes me feel sad which is not wise for we could not return to the old times again . . . Everything here is depressingly dull—no prosperity here outside of the hotels."

Two years later the Gilpins again returned. During this visit, Emma tried swimming in a hotel pool, even getting her hair wet. There was sailing on the lake, visits with old friends like the Kimberlys, Clarkes, Mulfords, and Deweys, and she even met Henry Flagler again. But despite being at the hub of things, she felt something was missing—possibly the unpretentious sailing and beach parties from long ago. The Gilpins tried to enjoy themselves but really didn't.

Thursday, March 9, 1899

Mrs. C. told me some funny stories of the "glory hallelujahs" now staying at the Poinciana where the women vie with each other in their display of gowns and diamonds. With her

*The Royal Poinciana, circa late 1890s. "An ugly barricade"
is how Emma described the view.*

nervous snap and vim she told of what sort of
people they had: "two chewing gums," "clothing
horses galore," etc.

Friday, March 31, 1899

We are very comfortable [at the Poinciana] but
pay the price. One soon gets tired of it for like a
giant spider's web, it holds you from more
legitimate Lake doings.

It's ironic that Emma, who once thought of entertain-
ing Flagler, should finally disapprove of the changes he
brought to the lake—of the *parvenu* people who stayed
in his hotels and of the way the hotels themselves,
specifically the Royal Poinciana, ruined the natural
beauty of the lake.

Friday, March 20, 1903

There were a dozen small boats in the inlet
with fishing parties from the Poinciana, one
could easily guess from the elaborately *en regle*
fishing costumes fresh from a New York store
which the gentlemen wore and the more painful

faded finery of the women who fished in veils and gloves . . .

The new wing of the [Poinciana] presents an ugly broadside up the Lake and with its eight stories overtops the trees to such an extent that Mrs. C. expressed her surprise at the lack of all beauty in what was so handsomely represented in the ad. pictures. It certainly is ugly—a big barricade.

The Late 1890s

The changes that Emma Gilpin predicted came true not only for the Palm Beach area, but for all of south Florida. Almost without stopping to build up steam, Flagler's railroad surged south after reaching Palm Beach in 1894. As tracks were laid and areas became accessible, small communities such as Delray Beach and Boynton Beach began to be settled. In these towns and others between the resort destinations of Palm Beach and Miami, farming, working, and merchant-class families were repeating pioneering experiences of twenty years earlier.

Three families—the Sterlings, the Budges, and the Murrays—all came to south Florida within months of each other in 1896. So rapidly was the region changing that while the Murrays had to disembark in West Palm Beach in January 1896 because that was as far as the railroad went, the Sterlings were able to ride it further south to Delray about ten months later because the tracks had been extended to Miami.

Ethel Sterling of Delray Beach, Stella Budge of Miami, and Florence Murray of Boynton Beach were young girls then, and their stories show us the gay and not-so-gay 1890s and the different stages of urban settlement during that time.

"You can't put me off here! I want to go to Linton," said Mary Sterling in late autumn 1896, using the name Delray Beach was then known by. "Lady, this is

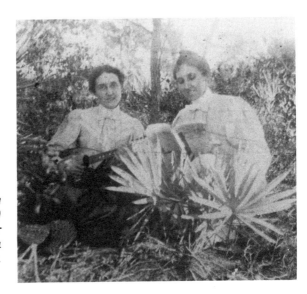

Mary Sterling
(on the right)
and her sister
Effie, circa
1898.

Linton," the conductor of the little wood-burning train replied.

Ethel's father had come to Linton a few months earlier to start the first grocery store or commissary. Five-year old Ethel saw nothing but scrubby palmettos, little pines, and deep white sand.

"'Where do we live?' mother asked as father took us to the commissary. 'Upstairs,' he replied, leading us up into the three bare rooms above the store. We had no stove or beds. It was very primitive with cooking being done outside using palmetto roots for fuel.

"I remember Mother looking at me and realizing what she faced. She had a hard time coming here from near Philadelphia. She began to cry as she looked at me and said, 'You poor dear. You will never see anything, hear anything or know anything here.' But my father told her, 'It's up to you whether she ever sees, hears, or knows anything here.'

"My mother dried her eyes, squared her shoulders and never faltered again from that time on."

Ethel recounted those memories in a taped oral history she made for her family during the 1960s and 1970s. But things didn't improve that rapidly. One

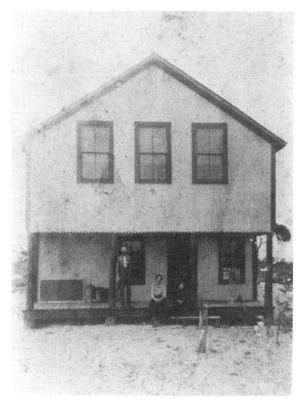

The Sterling commissary in the early 1900s, captioned "How It Looked When We Came to Florida."

photo from the era shows the Sterlings, some friends and some Bahamian workers preparing to butcher a turtle.

"We had no fresh meat except for whatever game or fish could be caught. Everything at the commissary was canned; salt pork was the only meat shipped in, and it arrived in sturdy wooden boxes that Father used to build our kitchen."

There was no way to keep ice at home, and the nearest ice house was in West Palm Beach, a day's ride away by horse and carriage. But there was a train to and from Palm Beach that did more for the residents than just carry freight or passengers.

"Sometimes, we'd go out to the railroad tracks, flag down the train and get the rare treat of a glass of ice water," Ethel recalls. "The train was also our quickest

Ethel (far left), her father Henry behind her, her mother Mary (next to wagon wheel and Bahamian workers next to a freshly caught turtle, in 1901.

means of communication because there were just sand roads going through the woods. If we had news to send, we'd meet the train, flag it down, and give the message to the conductor to take to the telegraph office in West Palm Beach or in Ft. Lauderdale. So much depended on that train. If there was a freeze coming through, a storm or a hurricane approaching, we'd learn about it by having the train whistle signal us."

Occasionally, the family attended concerts at the Royal Poinciana Hotel in Palm Beach. "Later I went to West Palm Beach for music lessons. The train would go north at seven A.M. and return south at eleven P.M. and someone would have to wave a lantern at the brakeman so he'd know where to leave me off."

Delray did prosper and eventually had a church where Ethel's mother sang in the choir. But shortages of supplies still upset Mary, especially after one funeral service.

"'You didn't have to nail him in,' Mother complained to Father, who had helped make the simple coffin. But it had been necessary to nail the coffin shut since there

were no screws left in town and a new shipment hadn't come in."

But by 1910, the Sterlings had settled in comfortably and Ethel was teaching school:

"Some of my students were nearly as old as I was, which made discipline hard at times. Once, two bigger boys tried to hide under their desks, and I decided to ignore them until, stiff with cramps, they came out on their own and got a scolding."

Like Ethel, Stella Budge's first home in south Florida was also above her father's store. Frank Budge moved his family and hardware business from Titusville to Miami by boat in March 1896, a month before the railroad reached town. Stella was five years old when her family reached the north side of the Miami River (at the foot of Miami Avenue today) where her father would build their first home.

Growing up in a city made Stella's childhood somewhat different from Ethel Sterling's. Miami had only about 1,500 people, according to the 1896 city incorporation papers. But the opening of Flagler's Royal Palm Hotel in January 1897 and the Spanish-American War in 1898 would bring great and sudden population growth, and there are hints in Stella's memories of the more negative aspects of city life. For example, the reason for the window shutters in this description of her first home is one that probably wouldn't have occurred to Ethel Sterling's father in less populated, more rural Delray.

"The sturdy, rectangular two-storied frame structure had large, paneless windows to allow breezes from the water to cool and let in light. The broad shutters gave shade during the day, as they opened upward like an awning. At night they could be locked down to secure the store from thievery and also act as protection from the seasonal storms . . . "

Stella Budge and her sister Fannie kissing on the porch.

"The upper story of the building, made into an apartment, was [our first home]. There was no running water, no inside toilet. A barrel outside the building caught rain water for household use. Mose, who helped in the store and home, would take [the] clothes in a row boat up the Miami River to wash them for the family."

On a more positive note, residents all knew each other in those early days, and an apparently insignificant social event like a bicycling party could become news, as this 1897 *Miami Metropolis* newspaper item shows: "On Monday evening last at about eight o'clock, a large and happy party of bicyclists was seen to assemble at Hotel Miami for the purpose of enjoying a moonlight ride. The party was captained by Harry Tuttle and escorted by Master Patsey [sic] Oliver and that charming little Miss Stella Budge."

Miami was small when Stella's family moved there in 1896, but two years later the Spanish-American War made it grow up almost overnight. The influx of troops based in the city brought a new, rougher element to the city. The sheer number of soldiers taxed the city's

ability to feed, shelter, entertain, and care for them, and the proximity of Miami to Cuba plunged the city directly into national affairs.

Stella recalls the war brought unwelcome changes for her family:

"Soldiers, seven thousand strong, [came] pouring in when the Spanish American War broke out in 1898. The mostly volunteer army was a tough bunch of men, many from the Bowery in New York. The influx of men in numbers that were more than the whole town's population . . . posed a problem for the community. Stores had to lock their doors. [Father] would only open to five customers at a time to keep control. Women and children were kept off the streets when the soldiers were on duty . . . "

"When the troops were encamped in Miami, a serious measles epidemic broke out among the soldiers. Citizens were warned to stay at home as much as possible to avoid contact with the disease. In order that his children could get out into the sunshine to play, [Father] had a fence put around the vacant lot alongside the store and added a sand box. [We] could play here in fresh air, yet not be in contact with the marching troops who were passing by on the dirt road by the store . . ."

"[I] also missed the pleasure of riding with Sam on the high wagon as he made deliveries for the store. Black Sam missed [me] too, for when I was along, the soldiers would not throw coffee and bother him or the mule."

A greater disaster struck Miami and the Budge family later in the year when the city saw the first cases of yellow fever brought back by soldiers returning from Cuba. About 263 Miami residents and thousands of soldiers died from the disease. The city was placed in quarantine, a special hospital was set up, and a fumigating corps was organized.

But Stella's mother still fell ill. Stella recalls that nurses were instructed "to keep cracked ice in the bath tub and put it in packs around [mother's] throat to

prevent the fatal 'black vomit' and to keep the fever down."

Stella's mother recovered, and Miami rebounded from the war and the fever:

"Miami grew rapidly and soon it was decided to pave the business section. It was quite exciting. On a Sunday morning . . . the sidewalks were lined with spectators to watch a crew of men lay impregnated wooden blocks. It was really something to be proud of in those days. But after the first rain, the blocks floated away, and the pride of Miami was absolutely impassable."

Paving blocks were not much of a concern for Florence Murray, whose family lived in a tent when they first arrived in Boynton Beach in January 1896. The oldest of ten children, Florence was the daughter of a farmer who briefly became a merchant before going bankrupt. Unlike Ethel Sterling or Stella Budge, Florence wrote her own recollections as much to express her feelings as to preserve family history. Her dry sense of humor comes through at times, giving her unpublished manuscript, written in 1965, a distinctly individual voice.

Florence Murray came to Florida as a six-year old child; her family had left their Michigan farm because of her father's poor health. "It was either Arizona or Florida so he and Mama decided on the latter," Florence wrote. Ironically, they originally planned to settle in Linton (Delray) where she might have been friends with Ethel; a quirk of fate left them off in Boynton instead.

"It was in the tourist season and everything was full. We [Florence, her parents Horace and Mary, and her two younger brothers Clyde and Glenn] finally spent the night in the attic of the old Hibiscus Hotel [in West Palm Beach which was as far as the railroad went then]. Dad was ready to go back but Mama persuaded him that they should go on to Linton, their planned destination."

Linton was seventeen miles south, so the Murrays set out by mail boat only to be deposited at Boynton because, according to the captain, the canal was "too full of lumps to go on." With promises to pick them up the following week, he put them ashore.

It was dark by the time everything was off and Dad asked a man who had come for the mail where Boynton was. "All around you" was the reply as he stalked off into the darkness . . .

After peering all around, a light was seen in the distance. We followed the narrow trail and came to a camp of surveyors who kindly asked us to have supper . . . and helped us put up our tents.

The next day we moved our tent a little farther away but still near the surveyors. They were camped in the yard of a Negro family named King. Their tents were pitched under large banyan trees on a green lawn. After their work was completed they moved away, and my brother Clyde and I spent many happy hours playing on this lawn and climbing trees.

The Kings had two sons that were much older than we were. King was a mulatto and well educated while Maria his wife was very black and roly poly. He was the overseer of the Flagler pineapple field and Dad and several other white men worked for him that first spring harvesting the crop and setting new fields, thereby learning how to do them.

In January 1896 Boynton was a town of tents occupied mostly by men who had left their families behind. Horace Murray decided to live there, too, with his family, in a tent.

For over a month before our freight arrived my mother had to cook over a camp fire in the yard. We had to eat before dark and get into the tent on account of mosquitoes. Glenn had colic every afternoon and it was my job to hold him while

Mama cooked. We were both in tears much of the time. When the freight arrived, Dad built a porch on the tent that was thatched at each end with palmetto leaves. The stove was on one side and we ate in the other.

Florence returned to Michigan that spring because there was no school in Boynton. Her mother followed her home that summer, and a sister, Eleanor, was born. They all came back to Boynton in the fall of 1896 to find a new home Horace had built out of lumber salvaged from shipwrecks.

When we got to Boynton I was delighted with the new home we had. Two stories with a large bedroom upstairs and two down. Large living room. Kitchen and dining room combined and front and back porches. We lived in this home for twelve years with kerosene lamps and no running water.

The winter after I left Florida more people moved in with children, and with Clyde, who was four, [we] had their quota of ten [so we got] a teacher. A Miss Maude Gee of Quincy, Florida. She boarded with my folks. School had started before we got home but I completed the second and third grades that year. The schools were not graded, and I was allowed to cover as much ground as I could . . . I never will forget how upset I was when Miss Gee spanked Clyde because of stuttering. He kept saying, "Miss Gee, I can't say 'it'." For one thing I think she was extra strick [sic] with us because she boarded with us and didn't want to be accused of partiality.

One Saturday she and I went to the beach to hunt for shells. And what did we see but a Mama bear and two cubs. The mother ran over the ridge out of sight and we gave chase to the cubs. My dad said we were lucky we didn't catch one because the old one hearing it squeal would have been at us before we could have let one go.

In those days towards the end of the century, Florence learned other lessons as well, especially about being willful.

There were large tomato packing houses built near the canal and in one of them the town had its dances. Now in order to have enough to make it interesting all ages attended . . . I could only square dance and of course hated to miss one. One night my Uncle Will asked me to dance and I answered, "I don't care." When the dance started he didn't come for me but danced with someone else. I was hopping mad. When I asked him why he said he never danced with girls who didn't care. You can bet I never made that reply again.

That same Uncle Will, who boarded with them briefly, was able to dare Florence into smoking when she was about ten years old.

[On a walk,] my uncle bet me fifty cents I couldn't smoke a cigar without getting sick. I did it. Then he said he would give me one dollar if I could smoke the second one. I started and about half way through I commenced to get sick. But I said nothing as we were leaving to go home and I thought the ocean breeze would make me feel all right. But on the way I threw the cigar away and when he noticed I didn't have it I told him I lost it. Contrary to my expectations, I was worse when I got to the beach. Before I got home they [Will and another friend] had to lead me. My mother owed that if he ever had daughters she would teach them to smoke. He later had four girls and I know some of them did smoke although Mama didn't teach them.

Florence was fully grown in height by the time she was twelve, and claims she was often mistaken for a much older girl. Her mother had two more children during that time, but Florence showed no interest in helping take care of them or the house. "I had the

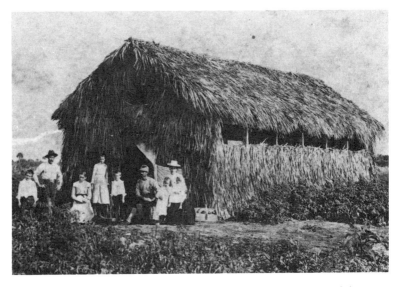

The Murray family, early settlers of Boynton, in front of their palmetto-thatched packing shed, circa 1900. Florence Murray is the tall girl standing fourth from the left; her parents are seated to the right.

babies trained so I could read while I rocked them which they would not let my mother do," Florence wrote.

Having completed grade school by the age of thirteen, she convinced her parents to send her away to school. Miami had the closest high school, but the family knew no one there for her to board with, so she went to a coed state school, The East Coast Seminary in Gainesville where she was the youngest student.

> Now all my life so far if I didn't get my own way I would throw a tantrum. As long as I had my way I was very sweet. All the town knew this and I was almost never crossed. My mother fairly agonized over me after I went to Gainesville thinking I would have an unhappy time. But as soon as I got there I realized I was a small frog in a big pond and had no trouble at all . . .
>
> Before I went my boyfriend and I became engaged, not officially, but my folks did say if we

were both of the same mind when I was sixteen
we could marry. He would be twenty-five. But
before the first winter was over, I decided mar-
riage was not for me—to him, at least. Wise
parents, I'd say.

About 1905, the state school was abolished, and
Florence returned home rather than go to Stetson
University, which had been the seminary's "greatest
rival," or to the women's college at Tallahassee, which
her parents considered too far away from home.

By that time my father had a general store. I had
worked in it the two summers and liked it. We
also had the post office in one room [and] we
lived upstairs and rented our home.

The townspeople had to go to West Palm
Beach for drugs, mostly patent medicines,
shoes, and dress goods. Drummers talked Dad
into stocking those things, promising all the
time in the world to pay. But the wholesalers
wanted their pay in ninety days, so Dad went
broke and into bankruptcy. A young lawyer,
Freeman Burdine, came up from Miami to in-
voice and sell the stock. When he realized that I
knew them all, he turned the selling over to me
on a commission.

As our house was rented, we moved to a
packing house in our pineapple field a quarter
mile west of town. It was hard on Mama but a
lark for the kids.

Shortly after that, Florence went away for a twelve-
week teaching training course and in 1906 at age
sixteen passed her teacher's exam. Although her first
teaching assignment was northern Florida, her experi-
ences, in a one-room schoolhouse with 67 students
and boarding out with strangers, can't have been that
different from those of teachers in south Florida.

My room was a shed room that had been added
on to the house. I had one window—no glass or
screen—only a wood awning that I could lower in

case of hard rain. My bed was a huge double feather bed. The first morning I tried to make it, and it looked like a relief map with hills and valleys. That evening I was told not to bother again. After shaking the tick good, they used a long stick to smooth it out.

My light was a kerosene lamp without a shade. Our bath was a wash bowl and pitcher, fence corners our toilets. I had pioneered at Boynton but nothing like this.

Our school restrooms were rail fence corners. The boys went one way and the girls another. Teacher just didn't go.

One little boy . . . was a victim of hook worm, I know, and feel sure he was a clay eater too. I showed the class a picture of a chair on the chart and tried to get him to tell me what it was. Finally, I said, "It's something we all have in our homes." I was speechless when with a big grin he said "Bedbugs."

Teachers were hired for specific sessions, and in Autumn 1906 Florence began teaching in Coconut Grove, where she became engaged to Jim Thompson, a fisherman and charter-boat captain, after knowing him for only six weeks. Florence didn't write much about her courtship but she did note that although Jim was thirty years old, fourteen years older than she was, he seemed much younger.

One day an old batchelor [sic] friend asked me when I planned to be married. Jokingly, I said I couldn't decide between April 1st and Thanksgiving Day. His reply was, "It will make no difference. You will think it's Thanksgiving and discover it's April Fool." Right then, I decided on Thanksgiving and told my fiance so.

Florence was married at age seventeen and became a mother less than two years later. Her earlier eagerness to turn over babysitting and housework chores to her younger sister Eleanor finally caught up with her,

making her a little unprepared for domesticity.

Jim's youngest brother, Jeff, and a cousin Cyril Bush, from Key West, were staying with us [in Coconut Grove]. They all went down to the boats at the Bay and I was alone. I had never seen a gasoline cook stove much less used one. I was standing there trying to decide how to light it when Jeff came to the house for a tool. He showed me how to light and regulate it. If not for him, I probably would not be here today. The seventeen-year old bride could have gone up in smoke . . .

I learned to cook enough to keep my menfolk from starving—they were very patient with me. There was one thing I could do—make bread.

One year Mom had made bread to sell in the town's store so that Dad could put in a tomato crop. Of course, it was an off year and Dad went broke and back to carpenter work. As she had to make four large dishpans of dough every night, Dad, Mom, Clyde and I each kneaded a batch. I really liked this and could make the best of bread—fine grained and light.

Florence kept on making bread until the middle of her first pregnancy; then her mother-in-law took over. "I kept on making bread until I got so large I couldn't do it. I never got into the habit again," she wrote. Florence had been preparing for a girl, but thirteen-pound Maurice was born two weeks after his mother's nineteenth birthday.

We were so proud of our boy altho I had been wanting a girl. I had rented a machine and made many fancy dresses and slips. All long, of course, and with yards and yards of lace and insertions. He couldn't get into one of them . . .

I was kept in [bed] for three weeks. At first I was anxious to get up but at the last was in no hurry. The day Maurice was three weeks old, the colored midwife and nurse left and I sat up to

bathe my son. Of course, I was fearful and very slow. About half way through he commenced to cry because he was hungry. I got so nervous I cried too. When [my sister-in-law] Ella, also eighteen, came in and found us both in tears she promptly took over and finished the job and I went back to bed. However, from then on I did it and that's about all I did.

Florence soon had another responsibility that was even more difficult to manage. When Maurice was about four months old, she and her family moved temporarily to her brother-in-law Charlie Thompson's home in Miami's Ft. Dallas Park. Florence was able to tie her young son to a dining room tableleg to keep him from crawling too far away, but her brother-in-law's pet chimp wasn't so easily controlled.

Charlie had a chimpanzee named Sapho. She had a nice house in the side yard and was fastened to a chain. I was deathly afraid of her but had to feed and give her fresh water several times a day. I would watch my chance and when she wasn't looking try to slip the pans to where she could reach them easily. She must have had eyes in the back of her head because she would whirl and grab for me. She never quite caught me.

One day she got her chain unfastened and was loose in the park. The Tuttle boys, Harry and Leonard, about eight and ten, were trying to help us catch her. She was having a ball in the large oak trees and eluding all of us. Finally I guess she got tired because she came down and ran up to Leonard [and] jumped in his arms and hung on for dear life.

He screamed, "I've caught her, I've caught her." However, she did the catching.

Florence's wry humor served her in good stead. She writes lovingly about the birth of her two daughters, Kathryn and Barbara, in 1913 and 1921; she describes

enthusiastically the summer fishing trips her family took together; and she writes poignantly about Maurice's death from lockjaw in 1921. But the picture that stands out most in her writing is that of a spunky girl growing up in hard times.

Making Do:
The Basic Necessities

Although the women pioneers came from different states at different times and brought with them different degrees of education, skills, and financial resources, two threads weave through their accounts of life during the 1870s—1890s: a concern with feeding their families and dismay over the inaccessibility of medical care. . .

Makeshift shelters such as tents, crude cabins or even palmetto shacks could be tolerated until better homes were built. Clothing could be patched and passed down from child to child, knowing that once cash from vegetable crops came in, yard goods could be ordered from Jacksonville or Key West. But food was an immediate, pressing concern, and the lack of a doctor could have serious repercussions.

These themes don't dominate entire letters or episodes in journals but they do emerge periodically in brief asides. Marion Geer, for instance, mentioned learning to substitute bear fat for butter in cooking in the 1870s and 1880s. Lillie Pierce learned to disguise the bitter taste of raw quinine—taken for fevers—by putting it in a spoonful of coffee. These snippets of information show how inventive and self-reliant these women had to be. The first settlers shipped in many supplies such as flour, sugar, and salt, but generally they lived off the land as much as possible. Ella Dimick, who arrived on Palm Beach in 1876, doesn't appear to

have missed much in her daily diet, as this later interview suggests:

The people who first settled in Palm Beach were not people of means, no means at all hardly. But they didn't need money much. It was nothing for my husband to go out and kill two deer just before breakfast just anytime he wanted to do so. Food was plentiful for everybody; no settler need go hungry or starve in what is now Palm Beach County. We had all the Palmetto cabbage, fish, turtle eggs, bear meat and venison we could possibly consume. Then as soon as we got our land cleared we began to raise vegetables in our rich hammock soil that would produce anything.

But the wildlife, climate, and insects also had a deleterious effect on the settlers' food supply. Possums, panthers, and snakes were likely to catch and eat chickens, which meant not only no poultry but no eggs as well. The heat and mosquitoes made it difficult to keep cattle. So Marion Geer, who shared the same menu as her sister-in-law Ella Dimick, wrote, too, about missing the fresh dairy products—butter, eggs, and milk—that were essential for baking.

For Lillie Pierce, the first girl to be born in what now is Palm Beach County, her family's food compromises were all she knew. While her mother, Margretta, complained about missing fresh milk and beef when the family came to Lake Worth in 1872, Lillie herself got so used to her mother's plain cooking that she would later tell an interviewer, "The first time [I] ever ate a cake that was made with more than one egg [I] could hardly swallow it, it tasted so eggy."

Ivy Cromartie Stranahan, born in 1881 and Ft. Lauderdale's first schoolteacher, also grew up in a family that had to improvise when it came to food. "The only soft drink we children had was called 'soda water' made from the juice of large rough lemons and water, sweetened with cane syrup into which we would stir a

pinch of baking soda to see it fizz," she wrote. Ivy spent
the first fourteen years of her life growing up near the
Peace River in Florida before moving to the east coast
of the state with her family in 1895. She remembered
a more vegetarian diet:

We had plenty of fruit, oranges, guavas, lemons,
grapefruit, wild berries and palm cabbage. We
grew our own vegetables—eggplant, tomatoes,
collards, cabbage, turnips, corn and sweet pota-
toes. I never saw a white potato [also known as
a "northern" potato] until I was an advanced
teenager.

One of the few women who didn't complain overtly
about having to learn to "make do" was Mattie Gale,
whose family homesteaded on Lake Worth in the mid-
1870s. Writing in the 1896 *Lake Worth Historian*,
Mattie, in a burst of civic pride, tried to turn some of the
disadvantages of Florida living into advantages. A year-
round resident, she surely knew the downside of
Florida's steamy summers, but she slides over that.
Perhaps what we're really reading was part of an early
tourist promotion campaign written by a woman:

A woman who has thoroughly mastered the art
of housekeeping in the North will find, on com-
ing to Florida, that she has many things to learn.
In this warm climate it is difficult for us to keep
cows, take care of milk, and make butter, all of
which is a large part of the housekeeper's work
in the North—especially if she lives in the coun-
try. Here we must depend on the canned cream
and butter for all purposes, and we soon learn to
use them with skill and taste . . .

All things considered, housekeeping is really
easier here than it is in the North. The weather
being free from either extreme heat or cold, our
freedom from dust, and the convenient and
labor-saving tin can, lighten the burdens of the
Florida housekeeper in a surprising degree.

While the burdens of housework could be somewhat

minimized, the almost total lack of medical care could not be ignored. Dr. Richard Potter, the first physician in Dade County, came to Miami in 1874, and until a handful of physicians arrived later in the 1890s with the coming of the railroad, he was the only doctor practicing traditional Western medicine.

Lake Worth residents eighty miles to the north must have known of his existence in 1878. Yet the settlers on Palm Beach chose to sail north to look for medical help when Ella and Cap Dimick's three-year-old daughter, Belle, broke her arm. Marion Geer, Belle's aunt, wrote:

> [An] accident which convinced us that some of us must study surgery or bring into our midst some one who had, occurred one morning when my brother's daughter, but three years old, fell in a skiff at the wharf where she was playing and broke her arm. Some of our men were able to set the leg of an animal so unfortunate as to need such services, but somehow veterinary skill did not suffice, and she was carried by sea and river to Rockledge, a distance of 125 miles, to Dr. Holmes. So it was, if any of our people were ill they must be placed in a boat and taken to the doctor, which, in our estimation, was quite as bad as living "forty miles from a lemon," for medicine we occasionally must have and lemonade we could do without.

The Lake Worth settlers soon acquired a physician when Dr. Potter moved there in 1882 but that meant that the twenty-five to thirty families who lived along Biscayne Bay had to either travel by boat to Key West— about 145 miles to the south—for professional medical care or else rely on Seminole herbal medicine. Mary Barr Munroe mentions an Indian doctor treating a Coconut Grove resident in 1886 but she doesn't specifically mention the ailment or the treatment.

Even in 1890 when Emma Gilpin visited the Miami area, the lack of a doctor offset any attraction Biscayne Bay may have had for her and her family. The Gilpins

had been stranded without a nearby doctor on the west coast of Florida in 1888 when Vincent, then fourteen, came down with a severe case of dysentery and micro-enteritis, and the family was determined not to run that risk again. Emma knew about the remoteness of medical care when she met Isabella Peacock's week-old grandson ("What a life of isolation and self-depend-ence! No doctor to call on short of Key West!"), so the Gilpins didn't seriously think about vacationing there despite the area's potential attractions.

Writing on April 15, 1890, she notes, "On this warm day we can imagine nothing more charming than this location for a whole season, where one could catch every breeze that blows and command innumerable pictures of grand beauty over toward the ocean . . . Very promising for a winter's stay, especially if there were a chance for a doctor."

By the late 1890s when the Gilpins did vacation at Coconut Grove, doctors were on the scene and Vincent was a young man in his twenties.

In the absence of physicians, mothers dosed their children with whatever was available. In an undated written account of her life, Ivy Stranahan recalled that,

"Fortunately, we were a healthy group of children for there were no doctors to be had. Our medicines were herbs found in the woods. Our spring tonic, Sasparilla, was made from the bark of the root of a small tree called 'Queen's Delight.' My mother made poultices for inju-ries from the thick, juicy India collard leaves which grew in the lowlands. She would hold the leaves by the fire to wilt them to make a poultice for the wound."

Lillie Pierce, living on Hypoluxo Island on Lake Worth, routinely "doctored" her own daughter Freda, born in 1896, with raw quinine as protection from mosquito-borne malaria and dengue fever. She also kept on hand calomel for chills and fevers and turpen-tine for bites and stings. Mothers used patent medi-cines; mustard plasters for chest congestion and aches and pains; castor oil for a laxative; poultices of epsom

Palm Beach bathing suit styles, in 1908, possibly similar to those described by Sarah Moses Dean.

salts for bruises or sore joints or as a foot bath; liniments for aches, and opium as a sedative and analgesic.

When these medicines didn't work, parents often had to seek medical help far from home. Ella Dimick was able to sail 125 miles with her daughter Belle from Palm Beach to the doctor in Rockledge in 1878, but usually mothers with small children at home weren't so fortunate and had to send their children off without them. Painful as these separations must have been, women bore them stoically; there was no other alternative as Susan King, one of the first settlers in Ft. Lauderdale after the train came through in 1896, recalled:

"We were getting along fine until my youngest son got poisoned and by the next morning was quick sick. His father took him to Palm Beach for treatment where he was relieved. His long curls were my pride, and when he returned his hair had not been combed and his trousers were on backwards. But I was so glad to see him well again."

Mrs. King's description of her son's disheveled appearance is unusual since the women generally didn't

Shop in Royal Poinciana Hotel, circa early 1900s.

write much about appearances or fashion. Yet it's the clothes of the times—high collars, long sleeves and heavy skirts—that makes it hard to imagine the women living year-round in this sunny, semi-tropical climate. One of the few to complain about the impractical fashions was Sarah Moses, who came to West Palm Beach as a thirteen-year old girl in 1893.

"We learned not to wear any [clothes] because they were so uncomfortable. It was hot in the summertime and I never got used to high necks and small waists and long skirts and was glad to get rid of them . . . By the time I married at twenty [around 1900], we used bathing suits [and] they were really quite pretty . . . black trimmed in white with full skirts and pop sleeves and sailor collars."

According to her account, young Sarah was the outdoor type who enjoyed fishing and boating. Once on a dare, she even tried to swim across the Palm Beach Inlet, so clothes were never that important to her. But for other women and girls, they were.

By the turn-of-the-century things had changed from the days when settlers had to depend on salvaging

canvas sails from shipwrecks for fabric to sew with. Nor did they have to ship in supplies long distances. Dressmakers, milliners, and dry and fancy goods stores in major settlements like Miami, Palm Beach, and West Palm Beach meant women could shop closer to home in 1900.

But many women still depended on a personal dressmaker or on their own sewing rather than on store-bought clothes, as Stella Budge described in this account of Miami in the early 1900s.

Ready-made clothing was not of the best quality at that time, and women did most of their own sewing. [Mother] made beautiful clothes for her children. [Stella had three other sisters: Dorothy, Helen, and Fannie.] There would be blouses with narrow, delicate border patterns of crochet on the collars and cuffs. White lawn "underthings" had lace and crochet trim. Lacy panels were used as inserts for skirts . . .

As gifts for each other, [we] would make neck bands which were very popular. [We] began with a short length of black velvet ribbon which [we] would purchase at E.B. Douglas or Burdines and Quarterman. The width would be folded under on each side, mitered at the end, and a snap fastener attached on the end point. Sometimes, [we] would add a bit of decoration in the way of a lacy crocheted band stitched to the top, which would fold down onto the black velvet ribbon. Beads made into designs or strung in rows across the velvet band would be something special. Whatever the pattern, it was a gift that did much to enhance the beauty of the high-necked blouses in fashion in that day.

As interested in clothes as Stella Budge was, dressing properly was even more important to the women who visited the fashionable winter resorts of Palm Beach and Miami around the turn of the century. Mary Lily Flagler, Henry's wife, was the prototypical

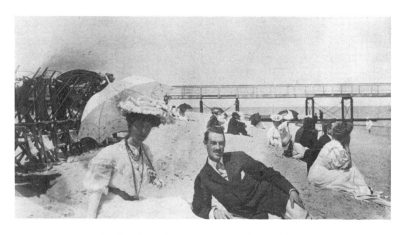

On the beach in Palm Beach, in 1906.

Candid of Mrs. Mary Lily Flagler greeting guests in 1907.

fashionable woman of Palm Beach in the 1890s and 1900s. None of her letters or personal accounts from this time are available, but society coverage from *Palm Beach Life* magazine indicates she was a woman who liked to dress well and often wore yellow, her husband's favorite color.

On March 31, 1908, one article noted that "[Mrs. Flagler] wore a pale yellow silk net ball gown [with] a

*A retouched photo of
Mary Lily Flagler,
circa 1911.*

long trailing skirt [on which] was a wide band bordering
of double gold mesh net . . . overwrought with exquisite
white and grey silk embroidery [and] supplemented
with heavy gold thread designs, delicately tipped with
pearls."

The next year on March 2, 1909, she still wore yellow:
"Among the many works of art which almost baffle
description we noticed Mrs. Henry Flagler in an exqui-
site creation of Empire yellow satin marvelously em-
broidered in white crystal and pearl beads."

And again on February 28, 1911, "Mrs. Henry Flagler
wore a stunning French gown of soft, clinging
Charmeuse satin with overdress of yellow chiffon,
heavily embroidered with seed pearls."

With this kind of traveling wardrobe, it's easier to
understand why this "disclaimer" was inserted into the
January 12, 1907 issue of *Palm Beach Life.*

Much sympathy has been felt and expressed
with Mrs. Flagler in her reputed loss of five

High society at Palm Beach: Swimming at The Breakers' Hotel pool, circa 1912.

trunks in the recent railroad disaster. As Mrs. Flagler has easily sustained the reputation of being one of the best dressed women at Palm Beach the loss would have been a grievous one, and her friends rejoiced at being able to refute the rumor as groundless.

Social reports in newspapers often printed detailed who-wore-what-to-which-affair descriptions like these. But Arthur Spaulding, personal organist to Henry and Mary Lily Flagler and a sharp observer of the social scene, noticed quite a difference in the fashions of men and women. In a 1907 letter to his parents, he wrote,

Although the women dress pretty elaborately on the whole, I am surprised at the unconvention- ality of the men. For example, I haven't yet worn and don't expect to wear my silk hat, or opera hat, and have only worn my frock coat twice. Men make formal calls and attend Fortnightly [Club] meetings in flannel trousers and wear straw hats with evening dress. Whereas a woman needs quite a wardrobe here, a man can

get along very well with a dress suit, flannel suit, patent leather shoes and white shoes.

Arthur Spauding's letters have a youthful exuberance ("Here I am on the threshold of high life"), and they show a much more candid picture of Mary Lily and life at Whitehall, the Flagler's Palm Beach estate, than the social notes and photographs of her do.

January 19, 1907

This picture . . . is a rather good one of Mrs. Flagler, although she looks a bit younger actually. She told me to be sure to let her know if ever I needed anything to make me comfortable. If she doesn't take care, I'll be asking her to darn my socks.

January 25, 1907

The more I see of Mrs. Flagler the better I like her and she is not at all the kind of woman I was prepared to see. Of course, she is not perfect any more than the rest of us are but there is nothing snobbish about her. If you treat her well and don't appear to be using her for what you can get, you can't ask for better treatment than she will give in return.

February 7, 1907

Last evening I went hunting for the first time—insect hunting. It began when Mrs. Flagler spotted a mosquito reposing on my shirt stud and destroyed it with her fan, thereby committing my shirt to the laundry. She, Mrs. Mitchell and I were chatting in the music room, Mr. and Mrs. Percy Rockefeller having left and Mr. Flagler having gone up to bed. Suddenly, I saw Mrs. Flagler's eyes become fixed on a dark spot on the drapery across the room, then grow wider and wider until finally unable to stand it any longer she crept over to the spot and gave a blood-curdling shriek which would have made the car-mule wild with envy . . . There in the folds of the drapery reposed the nearest approach to

a tarantula that I have seen yet . . .

Mrs. Flagler remarked this morning that she was afraid if the last morning's experience should be repeated, I would think there is more insect life down here than social life, but fortunately Whitehall is well screened and swept so that an experience like that could not be expected often.

The appearance of a tarantula—if it was a real one—was certainly a rarity. But the presence of spiders in the elegant corridors of Whitehall and probably ants, roaches and other bugs as well shows that all Florida housekeepers had some things in common, regardless of whether they lived in a marble palace like Mary Lily or in a palmetto shack.

The 1900s

Centuries are convenient marks to measure the passage of years, but time and history flow together on a continuum. It would be neat and tidy to think that south Florida pioneer days stopped in 1900 and twentieth-century progress began: that oil lamps, for example, went out in south Florida and electricity was turned on, or that women could spray the house with insecticide instead of setting the table legs in small cans of kerosene to keep the bugs from crawling up to the table top.

But that's not true. There was progress, to be sure, in some parts of south Florida. When the Royal Poinciana Hotel opened in Palm Beach in 1894 and the Royal Palm opened in Miami in 1897, Flagler provided guests with both indoor plumbing and electric lights. Businesses and private homes in Miami were wired for electricity in 1899, and by 1901, houses in West Palm Beach were hooked up to city water and sewer systems. For leisure, there was tennis, golf, swimming either in the ocean or in hotel pools, and dining out in restaurants.

But in 1899, one year before the century mark, Ft. Lauderdale had no more than about half-a-dozen families; Homestead, south of Miami, didn't begin to thrive until after 1904; and it was 1912 before the city of Lake Worth numbered 308 people.

The women who came to these towns, and others like

them, in the early 1900s had to face the same challenges other women had confronted twenty years earlier. The hotel where Florence Miller stopped in Lemon City during the winter of 1899-1900 was just a few miles from Henry Flagler's Royal Palm Hotel in Miami, but the amenities were years apart.

Florence, her husband Fred, and his cousin Will stopped at Lemon City, a community north of Miami, on their way to their farm near Arch Creek, on the city's outskirts. Back then, it took Florence and her husband a full day to reach downtown Miami by horse and wagon; today, the same drive would probably take fifteen to twenty minutes. It was 1899, but her experience was not much different from that of women moving to south Florida in 1879.

After loading up a freight car in Elmira, New York with everything that "would be needed for farming, clearing timber land, and for living in a wild, unsettled country [including] two horses and a man to care for them," Florence and Fred Miller traveled by boat and train to Florida. "From Jacksonville [south to the edge of Miami,] the Florida East Coast Railroad made regular stops to load on wood for engine fuel. It was not long before everything in the car was covered with wood ashes," she wrote.

Because Miami was still in quarantine from yellow fever, passengers had to disembark at Lemon City.

> It was eleven-thirty that night, with a beautiful moon, when we stepped off [the train], carrying our luggage, and made our way over a slippery sand road, through a vast expanse of scrub palmettos, quite some distance to the hotel. The building appeared to be of recent construction, just a framework sided with unpainted boards.

> Mother Carey, wife of the owner, opened the door to us, carrying an uplifted candle. She immediately informed us that she had a bed for the lady; after many changes a bed was provided for all.

I was grateful to find a clean pitcher of clean water, a bowl, and a pail in our room. [Cousin] Will had been assigned to a room with four others, so he brought his watch and purse to us for safe keeping. Then all was quiet until five o'clock next morning, when Fred and Will took the northbound train to look for our freight car.

At breakfast, served by Father Carey, with a portion of his egg still clinging to his beard, I found some interesting people waiting to get into Miami. Among them was . . . Frederick Morse, a Miami real estate dealer, who informed me that Florida was no place for women, just fit for men and dogs.

While waiting for her husband to locate their supplies, Florence learned a lesson about beachcombing that visitors today can still profit from.

A retired sea captain invited [another guest and me] to go with him on his sailboat [to the beach]. He furnished us with pails which we soon filled with shells. They were beautiful with bright, fresh colors, plentiful and of great variety. I filled the dresser drawers in my room with them, not knowing they were inhabited. In a short time, I was wiser and carried my shells outside.

After a few days, her husband returned.

They had located the freight car on a siding a couple of miles south of Arch Creek, as Arch Creek had no station or siding. With the horses and heavy wagon, they had hauled the freight to the camp site.

At camp I found a large tent containing a living room and dining table on one side, kitchen on the other, separated by a closet and a cupboard. Pine logs covered with boards made the floor, and the sides were boarded up a couple of feet. Canvas tent sides were hooked to the canvas roof and hung over the board sides.

Two tents provided sleeping quarters for the

family and one for the colored help, with a log shed covered with pine boughs for the horses. A water barrel was kept filled by a force pump.

The men were soon ploughing and planting potatoes, tomatoes, and cucumbers. Rough lemon seeds were planted for stock on which to bud grapefruit. Clearing of timber land came next, to get ready for a citrus grove. The acreage was partly covered with pine trees and palmettos, suitable for citrus growing, and the lower land, the prairie, was suited to vegetables.

The prairie was overflowed yearly by the Everglades, the border of which was only a few miles to the west. This yearly overflow washed out all acid left in the soil by the tomatoes, making it possible to grow the same crops on the same soil year after year. At all times the water was only a few feet below the surface. A corduroy road, built of logs covered with soil, crossed the prairie to make a usable road during the rainy season . . . Some days we shopped at the Lemon City dock, where a boat came weekly with groceries from Key West . . .

In the spring, the big flies came, as big as bumblebees. The horses suffered from their bites, one of which would cause a stream of blood to run down a horse's leg. Fertilizer bags were often converted into pants for the horses' protection. Mosquitoes grew so annoying at times that it became necessary to make bed curtains of mosquito netting.

Growing crops on 350 acres of land was beyond the capacity of Fred and his cousin Will, so the Millers had hired help who lived with them on this remote farm. Florence wrote her story during the 1960s in the middle of the civil rights period, which may account for the smug tone of this section.

To keep our colored help contented and willing, I prepared a simple but nourishing meal for

them twice daily, which they carried to their table at the tent. One day I overheard one of them, "Such rich food am making me fat."

This . . . trip of more than sixty years ago, was, in a sense, a successful experiment in inter-racial living and what in later years would have been just another pleasure trip proved to be the first of many happy years in Florida.

From that first winter of 1899–1900, Florence recalled trips to Miami for supplies from shops such as Frank Budge's hardware store. The Brickells, who had opened their Miami trading post in 1870, still lived on the south bank of the Miami River, just opposite the Royal Palm Hotel in the heart of Miami. Florence describes their property as being a thick hammock of woods with wild oranges, lemons, and orchids growing on trees. It extended from Biscayne Bay to the Coconut Grove Highway, a narrow road covered with crushed shell and bordered with a dense growth of tropical trees and shrubs.

Perhaps it was this natural barrier, a nearly five-mile length of tropical growth, that kept Coconut Grove from growing as rapidly as Miami. Even in 1900, it had no more than a few houses, according to Florence Miller. Residents of Coconut Grove found themselves in a curious kind of time-warp: neither caught up in the bustle of busy city life nor struggling with the environment the way settlers in more remote places were still doing.

It wasn't always a physically easy life but it was a genteel existence, and if Isabella Peacock and the Peacock Inn had been at the center of things in the 1880s, Jessie and Ralph Munroe were at the center in the early 1900s. Tourists came, but they were drawn by the sailing, not the social scene.

Ralph, a friend but no relation to Mary Barr Munroe, was the commodore of the Biscayne Bay Yacht Club which had become well known in boating circles. After his marriage in 1895, he and his wife, Jessie, also

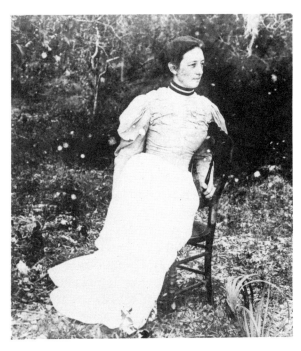

Jessie Wirth Munroe.

operated Camp Biscayne, an unpretentious resort with cabins and a dining room. Their daughter Patty was born in 1900, and her recollections of growing up there were published in 1977 in *Update*, a publication of the Historical Association of South Florida. This account is based on excerpts from that oral history and from a later interview with this author in 1987.

"In winter Mother and Daddy entertained the Camp Biscayne and cruising boat guests . . . Mother would serve tea at the drop of a hat . . . to anyone who came along . . ."

"When Mother was fourteen, she had infantile paralysis and it naturally weakened her whole system."

So in 1900 when Patty was born, Josephine Wirth came down to help her sister and never returned.

"[Aunt] Dodie was the only sister who wasn't married. She did the cooking, the laundry, kept chickens

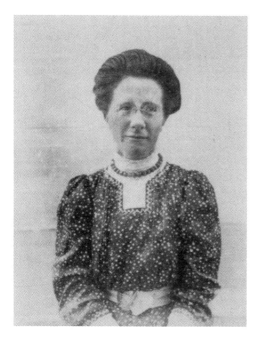

*Josephine Wirth,
Patty's Aunt Dodie,
circa 1906.*

and ducks, and even bicycled up to Brickell hammock one night to get the doctor."

Many Victorian households included unmarried women who devoted their lives to helping raise a brother's or sister's family, so Josephine Wirth was following an accepted pattern. But Josephine was so physically active compared to her sister Jessie that the situation sometimes became confusing for young Patty who felt, at times, as if she had two mothers.

"Aunt Dodie was strong; once she was rowing the boat for Daddy to catch crawfish and he caught a big one and it landed on the floor of the dinghy. I was scared to death of those crabs—it was my first experience with them so I went up and hung on her neck but she kept on rowing.

"Lots of times I used to wonder which one was my real mother because Dodie was so active."

There was a division of labor, however, with Jessie being responsible for the family sewing. According to Patty, her mother sewed what was probably the first

pair of ladies' pants that she wore sailing but Patty herself had more traditional clothes.

"What astonishes me now is the clothes we had to wear for sports. Mother made me khaki bloomers and a skirt to cover them and a blouse with a big band around my hips. It was so heavy that if we had fallen out I would surely have drowned . . . To make it worse we had to wear long black stockings . . ."

Those long black stockings were also inconvenient when Patty and Dodie went out picking key limes.

"We would put on straw hats with mosquito netting on them and long gloves and those long black stockings . . . The mosquitos were so bad it couldn't be done any other way although we usually sweltered."

Patty may have felt stifled by all that protective clothing, but a much more graphic picture of trying to stave off mosquitoes comes from Flora Hill Connelly who in 1905 settled near Naranja, about thirty miles south of Patty's Coconut Grove. Through her writing, we can see how different this "homestead country" lifestyle was from the bright lights of Miami, already starting to be called the Magic City by tourism promoters.

> My brother Will had taken up a Homestead and he asked me to help him . . . As my husband, the late John H. Hill, was located in Key Largo, helping to build the Flagler East Coast Extension Railroad, I thought it would be a good idea to come to Florida to help my brother.
>
> My husband tried to discourage me. He said the mosquitoes were terrible and that it would be hard for me and the children to endure them and the other hardships of the area. After due consideration, it was decided that I could make the move. After the furniture was packed, carted and "deadheaded" to Miami, the children and I

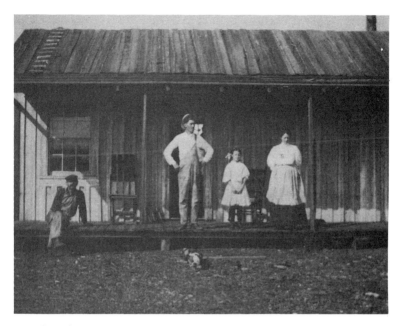

Unidentified house in Naranja, circa 1908, probably similar to the one occupied by Flora Hill Connelly.

boarded the Seaboard to Miami; then we trans-
ferred to the Florida East Coast Extension . . .
that ran as far south as Homestead. [The rail-
road had just reached Homestead in 1904.]

My brother Will met us with a horse and
wagon at Gossman's Siding, now known as
Naranja. When he came into the coach to get us,
I noticed mosquitoes, full of blood, hanging on
his face and arms. He was covered with them! I
recalled my husband's words of warning and
thought to myself that I had probably made a
mistake in coming to such a place. Nevertheless,
I was there and there was no turning back.

These last words of resolve echo the sentiments
expressed by Ethel Sterling's mother in Delray in 1896,
the momentary doubt about the so-called "Garden of
Eden" Marion Geer's husband had brought her to in
1876, and, in fact, probably the feelings of most women

pioneers no matter the date or the place. Historians have begun recently to look at the different ways men and women perceived the pioneering experience, theorizing that for men it was an opportunity for adventure while for women it meant a dislocation from the social supports of home. But the recollections of many girls who grew up in Florida show them greeting the pioneering experience with as much excitement, fun, and spunk as you might expect from any boy. "It was hard on Momma but a lark for the children," Florence Murray once wrote, suggesting that a prime way women saw pioneering was simply in terms of hard work done tediously day in and day out.

Fortunately, Flora Hill Connelly's brother gave her a short respite before she plunged into housekeeping. He even consulted with her before stocking up on supplies, but despite living with mosquitoes both he and his sister initially forgot about the need for mosquito screening, an oversight they soon realized.

> The first few days were spent with the Charlie Gossmans as the place that was to be our home was not yet fully equipped for housekeeping. No groceries had been bought as my brother thought I should help decide on what we would need.
>
> Old Cutler was the closest place for supplies and the trip had to be made by horse and wagon. There were no roads except those made by the Homesteaders . . . [They] would wind around [tree] stumps . . . and often the path was so narrow that the wheels of the wagon would almost scrape. The trip, . . . a very jolty one, was a distance of fifteen miles and took all day. In due time we made the trip and brought back enough groceries to last for several weeks.
>
> Will's house that was to be my home was one long room with a kitchen and porch tacked on the east side of the building. The furniture consisted of a bed, a dresser, and four home-made [benches]. There were no chairs. The

kitchen was equipped with a wood-burning stove, pots and pans and a rough table. The two smaller children and I slept in the bed. The rest of the family slept on the floor.

Mosquitoes were really terrible. They actually darkened the sun. We had no screens. The first few nights we managed to survive by means of my brother's smudge pot. This was a large pot or bucket into which he would put a few splinters of "lighter knots" (better known as fat pine) and ignite them to get the fire going; then he would add palmetto roots; on top of that he would place damp fertilizer bags to smother the flame and make a smoke.

This really didn't kill the mosquitoes. It seemed to make them doze a few hours.

While the smudge pot was designed to smoke out the mosquitoes, quite often the malodorous fumes would get to the human occupants also, making them cough and their eyes tear. Flora and her brother sought other remedies.

I told Will we would have to do something about screens. He made another trip to Old Cutler but couldn't get any screen wire. He made another trip and got some mosquito netting, which we tacked over the window and door of the main room. We closed off the front door completely.

My brother also brought back some insect powder to burn on tin lids which helped a lot. This along with the "smudge pot" and the netting made the main room very comfortable. The kitchen, however, was still in line of attack from mosquitoes as the netting gave out before we got around to the windows. Will had to stand over me with a brush when I cooked to keep the mosquitoes out of the food.

The early homesteaders of south Dade would turn to growing tomatoes, peppers, eggplants, and other vegetables for a living. But before they could farm they had

to clear the dense pine woods and scrub palmetto. For a newcomer like Flora, the virgin forest could be disorienting.

It was some time before I developed any sense of direction. All I knew was "straight up." Trees were everywhere around the house . . . Our nearest neighbors were the Charlie Gossmans who lived about a mile-and-a-half through the woods from us. I could more or less tell that direction by listening to the cackle of their guinea hens.

Panthers and bobcats roamed the woods at will. I kept a .303 rifle close at hand. Hardly a night passed but what I would hear the bay of the hounds, then the crack of a rifle and know that someone had shot some kind of wild animal. All of the early settlers had chickens and it was difficult to keep the animals from carrying them away. Another threat was hawks. A gun was a necessity at all times. Men even carried their guns to church.

Flora doesn't mention if she ever had cause to use her .303 rifle, but the tone of her account suggests she wouldn't have hesitated to shoot if it became necessary. But the "rugged woman" pioneer model she represented was beginning to disappear from the south Florida scene.

Women at Work

South Florida may have been a frontier in the late-nineteenth century but many of its values were those of mainstream America, and work outside the home wasn't a viable option for women. Some educated women did teach, but it wasn't until the early 1900s that more women began entering the business world. The 1904 city directory for Miami, for instance, lists seven female stenographers, eight clerks, one book-keeper and one cashier. The same directory had a separate "colored" section; in it twenty-nine black women were listed as laundresses, four as cooks, and four as servants, but it also showed one teacher and one nurse.

For poor, uneducated white women, the opportunities for work were limited. Unlike the textile mills of New England, the sweat shops of New York, or even the cigar factories of Tampa, there simply weren't many jobs in this rural area. Some women remember sorting tomatoes in packing sheds, but that was seasonal work and a way of "helping out" their farming families. Other women came to work in the big hotels or in the homes of wealthy residents of Palm Beach and Miami.

The women who did work usually followed the typical pattern of acting as their husband's business partner on a somewhat unofficial basis. Mary Brickell played an important role in running her husband's trading post in Miami; Isabella Peacock managed her husband's hotel in Coconut Grove; and Mary Sterling

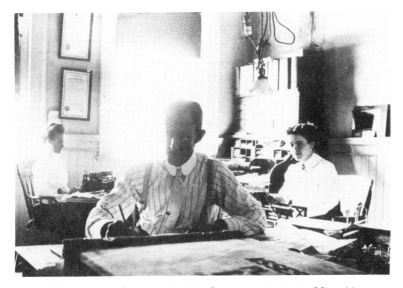

Addy Hurt and Antonette Harden, secretaries to Miami tax assessor James F. Jaudon, circa 1916.

did much of the purchasing for her husband's commissary in Delray. Other women in West Palm Beach and elsewhere helped to run small boarding houses or stood behind the counters in their husband's grocery, hardware or dry goods stores.

There were some self-employed dressmakers, but generally women who worked without male counterparts were widows. While some of these women entrepreneurs left written accounts behind, they reveal more about the commercial side of their lives than the private side.

One of the rare exceptions is a fragment of a letter left by Dr. Eleanor Galt Simmons, the first woman doctor in Dade County. Not much is known about her: she graduated from the Women's Medical College of Pennsylvania in 1879 and practiced medicine in New York and New Jersey until 1891 when she married Captain Albion Simmons, a lawyer who became a guava jelly manufacturer. When they moved to Coconut Grove the next year, she was thirty-eight years old and he was about sixty-nine.

Dr. Simmons paid housecalls on horseback and by boat along Biscayne Bay. Once she even treated an outlaw following a shoot-out with a sheriff's posse and refused his request for enough chloroform so he could commit suicide. Yet she also had a "domestic" side and was a member of the Housekeeper's Club; their minutes record her lecturing to them on health and hygiene and sharing her recipe for green mango pie.

What she thought of her life and practice can only be guessed at. But an undated letter on file at the Historical Society of South Florida suggests a certain ambivalence about women and the suffrage movement despite the independent life she herself had led. The letter is addressed to "Mrs. Blackwell," and it's likely it was written to Elizabeth Blackwell, the first woman physician in the United States.

> It is with much interest that I have been looking up the work of women in the field of pure science, and the number counts up well and the quality of the work done is good, considering how short a time women have turned their attention in this direction . . .
>
> [Most of these women] have received help from men because men were first in [the] field. Men support families—women also work for them but escape the rough and tumble of life. Men [are] always ready to help [and] their standard of excellence [is] higher than ours.
>
> Women are endangered of being spoiled because any performance outside the regular paths [is] considered wonderful [and] phenomenal. Intellectual women's suffrage will come by women gradually proving themselves efficient workers. Only that way [will it come], if it comes at all, by gaining positions of trust gradually and proving practically that they are capable of sustaining prolonged strain in civil as well as domestic affairs, [and] if [they] do nothing to disturb the sentimental relations between the sexes.

Money as a rule is the result of the surplus of enterprise of men, rarely of women. They are considered pretty good workers if they support themselves. We should not allow ourselves to be looked upon phenomenonlogically, if I may coin a word.

Much more typical than Dr. Simmons were the women who taught in south Florida. Teaching was a socially acceptable and somewhat predictable career for women for many reasons: it was consistent with the conventional notion of woman as nurturer and care giver, and it seemed especially appropriate on the frontier where women were thought to be civilizing forces bringing morality to saloon society and Indians alike. Teaching, in a sense, became the logical extension of the idea of woman as the "gentle tamer."

While movies may perpetuate the stereotype of the "schoolmarm" either as a delicate, genteel, young woman or as a crusty, old maid, women who became teachers in the late 1800s were really risk-takers. They set off for strange towns, usually without knowing in advance how they'd be received by students, what conditions they'd have to teach in, or with what kind of family they'd board.

Traditionally, pioneers have either educated their children at home—a task which usually fell to mothers—or sent them to distant schools. It's natural for people to think of building homes and supporting their families before turning to building community schools. For some south Floridians that process took too long. "At this time [1885-1886] there seemed to be almost nothing except a good school to make our home the one desirable spot of earth," wrote Marion Geer, explaining why she and her husband sold their Lake Worth homestead on the island that had become Palm Beach. And ten years after arriving in Florida, they went north to Michigan to educate their children.

Soon after the Geer's departure, the remaining pioneers on Lake Worth built the first school in Dade

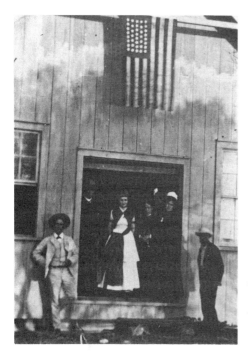

Miss Hattie Gale in doorway of the first Dade County schoolhouse, in 1888.

County, as most of south Florida was still called. It was situated on the east side of Lake Worth, almost in the middle of Palm Beach. Hattie Gale taught that first session in March 1886, and ten years later in the *Lake Worth Historian* she recounted how the school was established—a pattern followed in the next few years throughout south Florida.

When women want to raise money, they organize a sewing society . . . All through the long summer and fall [of 1885] they held their meetings at the homes of various members. This weekly gathering grew to be quite a social event, something to be looked forward to and considered. But the object was never lost sight of and fingers were busier than tongues.

The ladies undertook the purchase of the school lot. The county gave the district $200 which was sufficient to buy materials for a building 22 x 40 feet. The lumber was brought from

Jacksonville by schooner and unloaded on the building site.

Then the men, those very useful members of society, took a hand in the enterprise, and donated their labor . . .

With the rest of the $226 raised from selling their sewn fancy goods at a bazaar, the Ladies' Aid Society bought chairs—since the building was also going to house Sunday religious services—and some school supplies. But the students worked at a rough table, made from lumber scraps, which ran the length of the room; there was no blackboard and the school books, "a curious medley," as Hattie called them, were gathered up from people's homes.

That first three-month session was as much an education for the sixteen-year-old teacher as it was for her students, as Hattie recalled. "There were lessons learned by all, and some were not in books. The teacher was teaching for the first time, and it was the first school some of the pupils had ever attended."

Hattie had come to Florida to visit her father who had left Kansas in 1884 because of poor health. Having taken some courses at the state college in Manhattan, Kansas, she was chosen to teach that first session, but she herself must have realized the need for more training because she returned to school in Kansas sometime after the term ended. There she met and married William Sanders, and, according to different accounts, they returned to the Lake Worth area between 1887 and 1890.

In 1897, her sister-in-law Susan Sanders also came to Florida after completing her teacher training in Des Moines, Iowa. Twenty-one-year-old Susan stepped down from the train in the woods west of Stuart, near her assigned school. In her account, published by the Palm Beach Genealogical Society, she recalled arriving on a Saturday morning in plenty of time for the start of classes on Monday. With two children who had been sent to meet her, she set off for the home of the Lee

family, where she was going to board.

It was an awful rainy fall, and the woods were full of water. After walking down the R.R. [railroad tracks] for a mile or more, we struck out through the woods. It was cloudy and overcast, and in about two hours we were back to the R.R. tracks. We started again, but by skirting the big pond we found ourselves once again back at the tracks. So we looked for the next blazed tree before we would go any further.

We waded right through the big pond. We had only a peach and a pear to eat all day, which I gave to the children. One was a boy of eight, and the other a girl of twelve. The boy got wet and cold and began to cry, so I gave him my raincoat and plodded on through the ponds. There they began to tell me the ponds were full of alligators and cotton-mouthed moccasins, so you might know how terribly frightened I was, but on we went.

It became dark, so we squatted down by a big pine tree and waited.

Finally, around 10 P.M., after wandering around for about ten hours, a search party found them and took them home. Because Susan's trunk was still in Stuart, Mrs. Lee gave her some dry clothes.

The woman of the house was about my build, but a foot shorter. The mother and daughter had only one pair of shoes between them. The father and boys didn't have any. The father did have a pair of bedroom slippers which he loaned me. The mother got some clothes out of the trunk—a brown moreno [sic] dress with a train. I think she said it was her wedding dress.

The next day I burst out laughing, and I suppose they thought I was going crazy, until I explained how I happened to look down and noticed the big brown No. 10 [size] slippers. The dress just reached my knees (we wore ankle

length in those days), and the little train behind just grazed the floor. I did cut a funny figure, but after a big laugh the ice was broken, and we soon became acquainted.

Close physical proximity also would account for their rapidly getting acquainted, as Susan suggests in describing the family's sleeping arrangements.

They all lived in one big room—a bed in every corner, and one between the two long sides of the room. There were four or five boys in the family, besides two young boarders. I was assigned to sleep with the twelve-year old daughter. I said kind of hesitatingly, "Isn't there going to be any privacy for me to retire?" So they went to the boat, got the sail and draped it around my bed.

The Lees were able to improvise some privacy, but the style of living was still rough. Susan's bed was "a homemade affair, with a two-by-four down the middle, with barrel staves nailed from it to each side, and the mattress was filled with shredded saw palmetto leaves." The house itself was a palmetto-thatched shack with washed out fertilizer bags for window curtains. The one concession to gentility was a wooden floor and a separate cooking shed where basic, rough food was prepared.

The regular bill of fare for breakfast was unsalted oatmeal, gruel, fried salt pork, baking powder biscuits, and bacon grease to go on them. For dinner and supper we had black-eyed peas, sweet potatoes and grits.

Susan's salary was forty dollars a month, and board and washing cost her ten dollars. Like many pioneer teachers, Susan first taught in very primitive surroundings:

[School was] an eight by twelve palmetto shack with no floor, no desk for me, but a box to sit on. The children sat on a long backless bench, with a long slanting board in front to prop their book

against. There was a desk and bench down each side of the room, and a place for me to walk up and down the center.

According to Susan, there were five men to every woman at this time and by her accounts at least two of them paid some attention to her: one old "batch" walked out from Stuart (eight miles through the woods or twelve by the river, she writes) one Sunday bringing one big horse banana for everyone in the Lees' family and two for her. Another young man once rode out from Stuart on a horse, bringing a shoebox of candy when she wasn't there.

> They informed me that half was for the twelve-year-old girl . . . [so] we went into our bedroom to divide it. By that time, they had built a little frame work around the bed, and tacked up fertilizer sacks on it. After awhile we heard a noise, and looking up, we saw her three small brothers hanging from the rafters, like monkeys, watching us.

Despite the attention she got from these gentleman callers, Susan eventually married Harry DuBois whom she met when she was transferred the following term to a Jupiter school. During that first term teaching in Florida, she seems to have treated the lack of privacy and the pranks of young boys with a degree of good humor.

But discipline could be a problem for teachers, especially when students ranged up to seventeen years old. Recalling her days teaching school near Delray in 1910 when she was about nineteen years old, Ethel Sterling, who came to the town as a child in 1896, wrote: "Some of my students were nearly as old as I was which made discipline hard at times. Once two bigger boys tried to hide under their desks and I decided to ignore them, until stiff with cramps they came out on their own and got a scolding."

Even the slightly older, more experienced Daisy Lyman noted some difficulties when she came to West

Ivy Cromartie and her students, in 1899. Lula Marshall Pallicer is the blond girl in the checked dress in the front row.

Palm Beach in 1894 from teaching Indians in a missionary school in New Mexico. Flagler's workers were just completing final work on the Royal Poinciana Hotel and to stop them from camping on the Palm Beach site near the hotel, he had purchased a tract of land on the west side of Lake Worth where the equivalent of a shanty town went up in downtown West Palm Beach.

Daisy was twenty-three years old, the holder of a diploma from a midwestern teaching college. She had had two years experience teaching Indian students in Santa Fe, New Mexico, and she had just passed the second uniform teaching exam ever given in Florida.

Yet despite her credentials, the rawness of the town was enough to make her say, "Discipline was very hard to maintain, because it was a new community with people coming and going from all walks of life."

One of the few early teachers who doesn't seem to have been bothered by impertinence or any other breech of discipline from her students is Ivy Cromartie

Stranahan, who came to Ft. Lauderdale in 1899 as its first teacher. A pupil of Ivy's recalls her as being a stickler for details and accuracy.

"I was sent to school when five-and-a-half years old to make the nine children required for a public school," wrote Lula Marshall Pallicer, one of Ivy's first students. "[I remember] she asked me how many fingers I had. I was so proud to say 'ten', but I was wrong. She corrected me, eight fingers and two thumbs. That was a lesson I never forgot."

Ivy, an eighteen-year-old novice teacher, may have assumed such a stern demeanor to impress her students or it may have been inherently part of her character. A natural reserve shows through when she describes how Frank Stranahan, the postmaster and owner of a trading post, first began paying attention to her.

If I had mail and did not call for it, Mr. Stranahan would come over [across the New River] in his popboat with his lantern and deliver and this set everyone to wondering. I was indeed grateful but I could not understand all the excitement over such a simple kindness . . .

Certainly, the fact that she was a teacher impressed Frank Stranahan when he wrote to her over the summer of 1900 before their marriage. Even in the midst of declarations of affection, Frank often apologized for using business letterhead stationery and for his grammar.

May 4, 1900
Dear Ivy,

I note what you say as to [your] manner of addressing me in [your] letter. As usual will have to let you have your way . . .

Remember to be brave and true to me, and I think I can say you will not forget or regret the many pleasant days we have passed together lately, especially our last Sunday on the beach . . .

P.S. Excuse paper this letter is written on. Not

having "fair correspondents" lately left me un-provided.

May 31, 1900

It's getting very quiet here, no picnics to be heard of and most of the people getting away. Dull as it is, I can keep busy and live through the coming month with hopes of "more pleasant" days to come . . .

Will try and write occasionally but you will find me a poor letter writer.

August 10, 1900

Excuse paper this is written on. No time to look around for more . . . Our thoughts have surely been the same the past few days. That we only have one day more is a pleasure sure to think of . . . I'm getting the license. How do you wish your name to appear in it and age? . . . will close with love to the last girl I kissed good night. Our last letter for some time to come . . .

P.S. This has been written in rush. Overlook grammer.

Wild animals and ill-disciplined children were not the only hazards for a teacher. Hattie Carpenter, an eighteen-year-old from Columbus, Ohio, found that politics could also cause a young teacher trouble.

Hattie Carpenter moved to Miami from Columbus, Ohio in 1900 with her brother, three sisters, and re-cently widowed mother, hoping to start a new life. She had attended Ohio State University for six months, and had tutored Latin, French, rhetoric, and geometry, so she naturally thought of teaching once she got to Mi-ami. Yet despite her education she still had difficulty passing the qualifying exam.

I took the examination that spring and I guess I had the lowest grade ever given any human being down there. They gave me a third grade certificate, which is just the lowest you can get . . . For instance, they asked me to name all the war governors of Florida. I didn't [even] know

*Hattie Carpenter
(on left) and
younger sister
Louise, circa 1900.*

who the present governor was. They told me to
trace a water route from Kissimmee to Key West.
I couldn't pronounce Kissimmee, and I didn't
know where it was anyway. They wanted me to
name all the county seats and counties in Flor-
ida. I thought I was in Dade County but I wasn't
sure . . .

Then in arithmetic—I was smart in algebra so
I did everything by algebra so they gave me half
for trying because they didn't want to teach kids
arithmetic by algebra . . . Somehow they got me a
certificate—I don't think I deserved it.

Hattie ran into trouble with her first appointment
because of some articles she had written about Florida
for her hometown paper, *The Columbus Press-Post.*
How unfavorable these articles were remains un-
known; her ledger shows that she received four dollars
each for stories about Cape Florida, the Everglades, the
climate, and the East Coast monopoly [possibly refer-
ring to Flagler's business interests in the state]. How-
ever, they did create negative feelings about her.

They gave me a school down at . . . Larkins [in the area between present day Coconut Grove and Cutler]. Mamie [her younger sister] said, "I'll go with you every day and I will teach the children to sing . . . I'll play the organ and we'll teach them all kinds of things. We certainly will." So we were going to have more fun with our teaching.

. . . About that time Mr. Burtashaw [a resident of the school district] . . .starts out with a petition not to have me teach. They don't want any damn yankee teaching their children. And it turns out that . . . the same George McDonald [a supposed friend] that told me all about Indians and animals in the woods had copies [of the *Press-Post* articles] and he would read them aloud to them down there at Larkins—some of them didn't read . . . So he put in all the awful things that I wrote about them. Well, naturally, I don't blame them for not wanting me so I didn't have any school.

Hattie could understand the feelings of those parents but she wanted a job. Confronting a patronizing school official, she used the situation to get an assignment to teach third and fourth grades at the Miami Grammar School.

I went to Mr. Z. T. Merritt, who was superintendent of schools, and I said, "Mr. Merritt, I will sue the county because you gave me a school and I didn't get it." So he said, "Look here, Harriet." (He always called me Harriet.) "Play around a few years." I said, "Great Scott! I'm as old as any teacher you have down here. I'm older than Kate Collier." Well, she was three years older than I was, so he said, "You are?" I said, "I certainly am, and I don't like the way you are treating me." He said, "Alright." I said, "I want to teach in a Miami school." "Oh, no, I can't do that," he said. But they did.

The only direction Hattie was given at the start of

school was to keep discipline in her room. She's refreshingly candid about that first year.

I told the [children], "We want to be the quietest people that ever was. We will pretend that we are hunting deer all the time. When you go downstairs, you go like hunting deer, and go outdoors before you speak." Well, I got a reputation for being a wonderful disciplinarian . . . I'd [also] tell them [the students] if they would keep quiet I would tell them stories, so I would tell them stories the last half hour in the day.

We had a perfectly awful principal . . . His name was Faris and he spoke eight languages and he was very, very smart. [One day] I [had] put the tables on my board: 1x7=7; 2x7=14 . . . He came in my room, picked up the eraser, rubbed it off and said, "Oh, Miss Carpenter, you shouldn't teach tables. You should teach facts." I followed him out in the hall and I said, "Look here. If you ever again come into my room and make me look ridiculous before those children, I am quitting . . . It is the rudest thing I ever saw."

Before Mr. Faris left the school at the end of the year, he and Hattie had worked out some accommodation, and she was assigned to teach sixth grade in 1901. If administrators didn't intimidate her, neither did older students.

Nobody had ever thought I would be such a good disciplinarian so I worked a rabbit's foot on them too. I just treated them nice. I called all the boys "sir" and all the girls "lady."

I had Lucius Bennett; he was a very bad boy . . . so they demoted him . . . and sent him to my room . . . I said, "Well, we are so glad to see you. Now pick any seat in the room that you like." "I want that last one in the corner." "All right," I said. "Stella, Stella Budge, will you take out all your books, please, and move up here by me. Lucius wants that seat." And he said, "I don't

want any girl's seat . . . I will sit up there close to you."

And I said, "Close to me. Oh, I would never sit up close to a teacher. It is miserable. She is always nagging at you." He said, "I'll sit there," [and] he came up and sat.

After a bit I went to the board and we were diagramming sentences. I said, "Lucius, come up here." He came up. I said, "I don't know a thing about diagramming sentences. I never did it in my life and I am supposed to teach these kids diagramming. What's wrong here?" "Well, so and so," he said. I said, "How do you do it here?" and so and so and so and . . . he did the whole lesson and I said, "Thanks so much. I wish you would kind of watch for my mistakes because I don't know anything about it." Well, you know I had the loveliest time in that class that year.

When Hattie taught, educators had to be prepared to teach almost anything. To qualify for her state "life" certificate in 1903, Hattie crammed for and passed tests in twenty-two subjects. She also got a letter of recommendation from the once-despised principal, Mr. Faris, who put aside his own differences to write this glowing account of her, albeit with a touch of revenge in the final phrases:

I have found Miss Hattie Carpenter a remarkably efficient teacher . . . She arouses the enthusiasm of her pupils, introduces appropriate novelties without violence to systems, is singularly happy in individualizing pupils and at the same time carrying her classes forward in mass, flings energy into the task of the moment without either evidence of strain or forgetting limitations of time and place, displays ingenuity and resourcefulness, is bright without flippancy, and wins the regard of her pupils without lowering dignity or excellence . . .

It was clear to me from the first that she has a genius for teaching; during this interval [between 1900-1903] her genius had plainly had the harmonious development to be expected under the inspiration of moderate opportunity and the whip of industry.

After teaching Latin in the high school, Hattie became principal from 1907 to 1910. But the status of that position didn't compensate for the overcrowded teaching conditions. Hattie complained about students being without seats or books, classes being held in hallways or outside on the lawn, and about not having the resources to offer all the courses described in the high school catalog.

Maybe it was because of the conditions she describes that Hattie "got so fed up" with teaching and became a writer for the *Miami Metropolis* in 1910. "In those days we had such wonderful exciting times, and so much politics," she recalled of the rivalry between her paper and Flagler-backed *Miami Herald*. To that job also, she brought her skills and enthusiasm—qualities she shared in common with other women who worked in the early days of Florida.

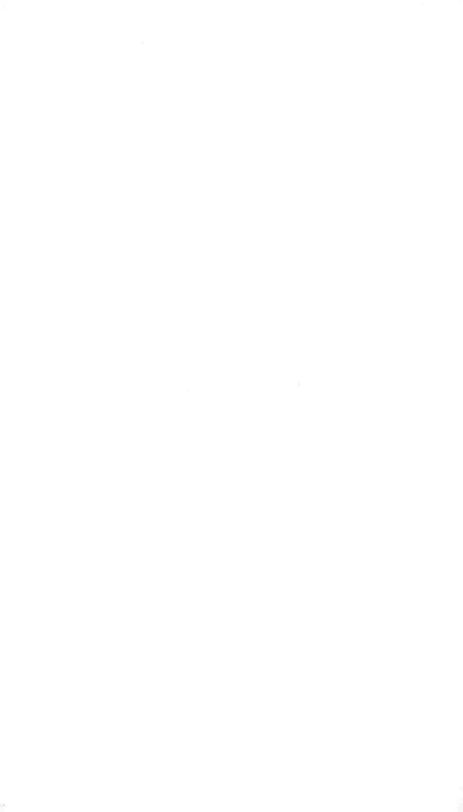

Not Quite the Wild West

I ndians have always been part of the mythology of the American frontier, but by the time most whites started settling in south Florida in the 1870s, the Seminoles were few in number and lived hidden from the public eye in swamp lands no one wanted. In reality, Florida Indians probably had more cause to fear the settlers than the pioneers had reason to fear them.

The Second Seminole War (1835–42) had forced about 3,800 Seminoles to move to Indian Territory in Oklahoma while a remaining few hundred escaped into the Everglades. Considered one of the fiercest wars waged against American Indians, the seven-year long military engagement cost twenty million dollars and left 1,500 Army soldiers dead plus uncounted Indians and civilians. No peace treaty was ever signed, and in 1856 the much shorter Third Seminole War broke out. When that ended in 1858, it's estimated that only 200 Indians lived in scattered camps throughout the Everglades and Big Cypress Swamp.

Rather than one cohesive group, the Seminoles were originally a mixture of Creek Indians who had been pushed south from Georgia by white expansion, the remnants of some tribes native to Florida, and runaway slaves. Supposedly they got their name from the Spanish word *cimarron* meaning a "runaway" or a "savage." But in the words of women who encountered them between 1870 and 1910, they don't appear savage at all,

At a Seminole Indian camp, in 1906.

and by then they certainly had no place else to run to.

An early and very detailed account of one woman's experience with the Seminoles comes from Emma Gilpin's 1890 journal. Emma, a mid-fortyish matron, had just "discovered" Lake Worth that year with her husband and teenage son, and they were capping off their winter visit with an extended sail down to Biscayne Bay. An inveterate collector, in days before conservation-consciousness, Emma was eager to buy what she could from the Seminoles: deer hides, alligator skins and teeth, and bird plumes. At times, her enthusiasm for souvenir shopping led her into bartering with the Indians without the aid of an interpreter.

But she was also an inquisitive and educated traveler, so she observed their appearance and behavior closely. Some of her comments, such as those about the strong, muscular legs of the Indian boys or the way a husband turned over money to his wife, are not quite what you'd expect a Victorian woman to notice or write about.

Emma's first encounter with the Seminoles occurred

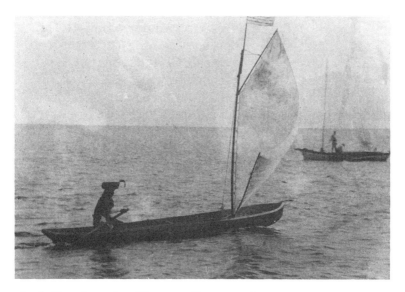

An Indian dugout on Biscayne Bay, circa late 1880s–early 1900s.

when the boat her family had chartered from Lake
Worth arrived at the Lemon City dock on Biscayne Bay.
Her journal starts on Friday, April 11, 1890.

To my delight I saw the dock was full of Indians
and with them were their squaws and papooses
and canoes full of camping outfits. They had
been hunting deer and were selling out and
laying in stores for a fishing trip up the Snake
Creek— twenty-five miles above.

They had sold out their trophies before we
came, but I went among them at once and asked
for deer skins, horns, and alligator hides but
they had done [finished trading]. Mr. Hill's inter-
preter [Mr. Hill was a member of another group
that had sailed down earlier from Lake Worth]
spoke to some for me but I found one [Indian] who
could talk very well and he told me he could sell
me a fawn skin.

I went with him to his canoe where he found
it— a little spotted fawn, dried on a palmetto
bow— price twenty-five cents. I bought it.

Another had a deer skin which we bought for forty cents and found they sold alligator skins for ten cents a foot of length. Had sold all out, however, and I found the storekeeper had some which we had measured at once, but could not find enough to fill half a barrel [so] leave order for him to gather some during the week.

The Hill party want to photograph the Indians but the women positively refuse though the men and the children are pleased to be "pictured" . . .

The squaws were dressed in blue calicoes trimmed with red, white, and yellow ruffles or bands. How they make them is the marvel. Around the neck of each squaw, big or little, were strong rows and rows of beads—heavy glass, blue and white weighing from four to twenty pounds. The belles or wives of the Chiefs having the addition of a necklace of silver coins. The little girls [are] dressed exactly like their mothers.

The boys up to sixteen years wear only a muslin or calico man's shirt and walk about with their muscular brawny legs showing up to their hips. They all look to be very strong and muscular. It is said the development of muscles is owing to their continual use of the canoe which is a dugout of cypress, twenty to thirty feet long which they propel by poling or paddling. The canoes contain all that is necessary for living on their nomadic expeditions from point to point. Camp kit— dogs, chickens, terrapins, venison and children.

They are good dealers, know the value of money thoroughly, can count it easily and they always pay money for what they buy. Their word is thoroughly reliable and they come when they say they will. They like to run accounts with the store keeper which means that they will come back there to deal again, and they always pay

such accounts.

Their beads have some special meaning and are taken off every night and counted and put on every morning and "counted again." The case in the store was full of glittering jewelry which they buy as ornaments.

The men wear woolen men's clothing—usually flannel shirts, pantaloons and vests, but one had on a full suit of navy blue flannel and a stiff *white collar* and a derby hat! A dude certainly. I think the collar was not attached to a shirt at all—only buttoned in front with a brass collar button.

A week later, Emma meets the Seminoles again further south on Biscayne Bay at the Brickell trading post. The Gilpins didn't photograph the Indians, in deference to their wishes. But Emma's description of their appearance, their eating arrangements, and the way one Seminole husband treated his wife is almost detailed enough to read like field notes from a modern anthropologist. She writes on Friday, April 18, 1890:

Get from Mr. B[rickell] nine alligator skins, a white heron plume and a white egret—very pretty specimens of both—$1 and $1.25 . . .

The Indian canoe is here and the family taking its dinner under the trees. Proves to be a pure Indian—"Young Tommy"—with pure Indian dress on: buckskin leggings; Indian coat, belted in of bright, colored cotton goods; and a curious turban on the head made of a bright, colored little shawl wound round and round . . . It is taken off and on easily just as a hat would be used.

His hair was cut in shingled bangs from the crown forward except his scalp lock which was plaited in two little tails. His wife was a laughing, cheery creature, dressed in the bright calicoes we had seen on others and her neck loaded with strings of beads from shoulder blade to ears of dark blue, light blue, red, white and green and below all a string of silver coins.

The two children—young—a boy and little girl were dressed likewise—the boy's hair cut close to [the] head except a long ridge from forehead to neck like a mane. The little girl had a dress just like her mother's down to her heels and [her] hair twisted in a knot on top of her head and cut in straight bangs in front.

In their dinner, prepared on shore, they had a full compliment of modern cooking tools and seemed to have plenty to eat, and I saw they had saved the coffee grounds in a tin cup for the next boil. After the meal, the mother and children marched to the canoe carrying the pots and kettles and pans.

Saw a good doeskin in the boat for which I offered twenty-five cents. He said, "Fifty cents" and consulted his wife who held on to her price which we paid, seeing it was an extraordinarily nice skin. Gave a silver half dollar which he at once handed to *her* and she in turn handed to the little pickaninny in her arms, not withstanding the risk of a fall overboard—as a pacification probably—for the child evidently was frightened at the sight of strangers and cried very decidedly and lustily.

The theme of the Indians being good, reliable traders appears repeatedly in many women's accounts, and the relationship benefited both the Seminoles and the settlers. Since the early eighteenth-century, the Seminoles had traded with the Spanish and British for ammunition, fabric, and some food supplies; in turn, the settlers, then and later on, counted on the Indians for fresh game as well as hides and plumes for the millinery trade.

"The Indians were very peaceful people and we always looked forward to their coming because they brought us fresh venison which was a delicacy [in the 1890s] because we didn't have fresh meat and were dependent on canned meats, salt pork and ham," wrote Ethel

Sterling Williams, daughter of Mary and Henry Sterling who ran the Delray commissary in the 1890s. The Seminoles came to Delray to buy things at her store and to order items from the Sears Roebuck and Company and the Baltimore-based Butler Brothers' mail order catalog. The following experience is the only mention found of the Indians not returning when they said they would, and Ethel herself sought an excuse for it.

The Indians would stand by the hour looking at the catalogs on the counter and they would order things that they would want. They'd say they'd be back in one moon or two moons and they would always come back and get it.

But one time they wanted to order a hand organ, and Mother was filled with consternation. She went to my father and said, "Harry, I cannot order that." He said, "The Indians are very truthful people and they always have bought what they want so you might as well order for them and get a couple of music rolls for the organs as well." Much against her will, she placed the order. The organs arrived, and the moons passed, but the Indians never came back for the organ . . . It was the only time I ever knew an Indian not to keep his word. Maybe something happened to that particular Indian.

Like pioneer women everywhere, Ethel's mother had to get used to the Indians who'd camp out in the backyard of their Delray home.

One evening when my father wasn't home, my mother, my aunt Effie, and I were sitting at the table in the kitchen shed my father had built. The window frames had been made out of salt pork boxes and were screened to keep out mosquitoes and sandflies. Suddenly, my aunt looked like she was going to freeze in her seat. "Sis, look," she said and we raised our eyes and saw two little black eyes peering through the window screening. It was one of the Indians.

Seminole Indian women and children, early 1900s.

Finally, he walked into the kitchen and said, "Me want pot." My mother looked at him and said she had no pot. But at that time we were using an iron wood cook stove, over in the corner, and there was an iron kettle on the stove. The Indian looked at it and said "Yes, you do." He walked over and took the pot from the stove and turned to my mother and said "Me bring it back."

My mother was breathless that the Indian would come into the house . . . In a few minutes, he came back and said, "Need a spoon." Mother said, "I have no spoon." He looked at her disgustedly and said, "Yes, you have spoon," and hanging behind the stove was a big iron spoon on a nail. He walked over, looked at her, took it and said, "Me bring it back."

The next morning he brought both the pot and spoon back—cleaned—and put them back where he had gotten them from. I suppose mother often wondered what he had thought of her when she deliberately told him that she had

no spoon and no pot and there they both were. But she always took a great deal of pleasure in telling this story on herself and the fear she had had. But from that time on, she didn't feel alone when the Indians were camping in the backyard.

Mary Sterling adapted well and quickly to the Seminoles who'd visit her and her husband's store. But many people's conceptions of Indians in the nineteenth-century were shaped by stories printed in dime novels: captivity accounts where white men, women, or children were kidnapped by "savages" and forced into lives of degradation until they were rescued and restored to the bosom of their families. So for many newly-arrived Florida settlers familiar with these tales, the appearance of the Seminoles could be very threatening.

Lillie Pierce was just a few months old during one of Margretta's first encounters with Indians on Lake Worth in 1876. Too young to remember the episode at first-hand, Lillie probably grew up hearing about it from her older brother Charlie or her mother. Lillie's father was away from home one day when a Seminole walked in on her, her brother, and mother.

> In walked a big Indian [with] a knife in his hand. My mother was wearing a very pretty bright red flannel jacket she'd made out of some stuff that came off the "Victor" shipwreck. [The Indian] laid his knife on her arm and said, "You got any more like 'em?" She said, "No." So he didn't bother her anymore.
>
> He went off [but] my brother was afraid that the Indian was going to give [us some] trouble so he edged into the dining room where the shotgun was and he was going to shoot the Indian but he didn't get a chance. The Indian went off and Charlie went up onto the roof and watched him go way off through the underbrush to the scrub until he was sure he was gone.

It's interesting to note that it's twelve-year old Charlie, not Mrs. Pierce, who goes for the gun. Eventually,

the Pierces and the Indians became more comfortable with each other. Lillie remembered getting a silk handkerchief from one of them and told a story about the Seminoles and a food safe her father had built:

> In those days people had to build a kind of big cupboard . . . of wood with a screen all around to keep food in . . . You set the legs in tins of water or kerosene to keep the bugs out . . . Father was working on one when a couple of Indians came along and said "Pierce, what you making?" My father said, "Cage to keep squaw and papoose." They looked at him and they looked at that safe and said, "Pierce, you lie too much."

If the Seminoles couldn't quite appreciate Hannibel Pierce's sense of humor in 1876 when they themselves were first getting used to more whites settling the area, they could be more sensitive to one little girl's curiosity about them in the 1890s. Fannie Budge first saw Indians in her father's hardware store where they would come to trade nails, fishing tackle, knives, and mosquito netting for fish and deer meat. Fannie was three years old when her family had left Titusville for Miami in 1896 and she had been left behind temporarily with grandparents. Her older sister Stella writes about Fannie's first reaction:

> Fannie was . . . in the store when a big six-foot Seminole chief entered. He was dressed in typical short, male Indian dress, wearing a turban wrapped around his head, adorned with an egret feather. Fannie was fascinated as she watched him wandering about looking at the merchandise.
>
> Walking from behind a bank of nail kegs, which were in front of the counter where the Indian had stopped, Fannie, for a moment stood transfixed at the sight of this large, brown giant. As if to make sure he was real, she quietly walked up behind him and gave him a pinch on the leg! In surprise, the Indian looked down into the blue

eyes of the young child. His smile reassured her he definitely was not a "wooden Indian," but a fascinating kind of person she had never met up with before.

While all the accounts by women suggest positive relations with the Indians, historically, the Seminoles had not always been treated well by the whites. So it's not unnatural that they may have felt some animosity towards the settlers occasionally. Lula Marshall of Ft. Lauderdale is one of the few white women to ever describe some hostile behavior on the part of the Seminoles.

Lula's family came to Ft. Lauderdale in 1895 before the railroad had reached there. Her father had moved the family, including eighteen-month old Lula, to a homestead on the New River where he intended to grow tomatoes after losing his north Florida orange grove to the freeze of 1895. Lula tries to show how frightened her mother was of the Indians, and perhaps as a woman alone with children it was justified. But unknowingly, perhaps, Lula still shows that the Indians had a sense of honor about trading.

> When I was a little girl I recall my mother telling me about the Indians coming to our home in canoes. My hair was blond, and the Indians would point their fingers at me and laugh as all their children's hair was black. When my mother was alone, she would take us children and hide in the palmettos until they went by as she was afraid.
>
> At night the Indians would come by and call out "White man, white man," and when my father would not answer, they would say, "White man, holowagus," meaning "no good." They would also take tomatoes and leave bird eggs.

The south Florida woman most publicly associated with the Seminoles was Ivy Cromartie Stranahan, the first schoolteacher of Ft. Lauderdale. Ivy never taught the Indians in any formal, official capacity but she

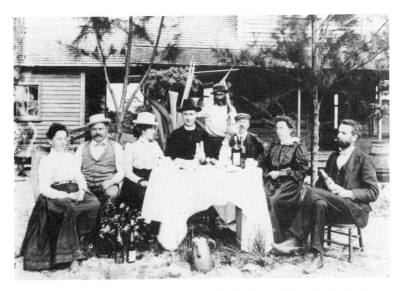

Mr. and Mrs. George Zaph (on the far left) and friends, including Father Kennedy in April 1900. George Zaph, a West Palm Beach hotel and bar-owner, was remembered by Ivy Cromartie Stranahan for selling liquor to the Indians when her own husband wouldn't.

became familiar with them after her marriage to Frank Stranahan in 1900. He had opened a trading post in 1893. As many as a hundred canoes at a time would come down the New River to the post where the Indians would camp for a few days, and Ivy claims she never feared them. But she does mention in a written account that her husband made the Seminoles stack their guns in the back of the store as soon as they came in and that he never sold them whiskey.

Ivy is known for her work in helping them settle the Dania reservation in the 1920s and for her efforts on behalf of their education. She became involved with the Indians right after her marriage once she stopped teaching public school. In a sense, she may have used the Indians as a substitute for the circle of family and friends she had left behind in Lemon City or for the schoolchildren she no longer had.

I was reared in a large family and with so few people and social events, my young married life

might have been a little lonely had it not been for the Indians coming to my husband's trading post. Mr. Stranahan was very popular with them because of his fair dealings . . . [and] as his young bride, I was closely observed.

In her account of those early days, written admittedly for a public audience, Ivy describes how she began teaching the Seminole children simple kindergarten songs and then gradually introduced them to Bible cards. Her concern with bringing Christianity as well as literacy to the Indians parallels that of other pioneer teachers who went west to "tame" the Indians by bringing them the skills and morality deemed necessary to function in the white world.

The Seminoles were curious, particularly the children . . . I would notice two or three groups of children standing some distance away waiting for a glimpse of me. I was anxious to know how they were going to accept me. I would go out on the porch, smile, and ask them to come into the house. At first, they were shy and reserved and would respond only with a faint smile. Not knowing a word of Seminole, I wondered how I would ever gain their friendship. What I did not know was that these children knew many words of English—enough to know what I was saying.

In a short time, they accepted my invitation to enter the house and what fun and excitement they had in exploring the different rooms, trying on my hats and clothes, and admiring themselves in the mirror. These stoic, silent little visitors would break out in spontaneous laughter, seeing themselves in white man's clothes. I soon realized that they were like other children except they had been taught to be shy of the white man. My motto was patience and perseverance.

As time went by, they became friendly and gathered in great numbers at my door on their

return from hunting trips. I would always be prepared with new pictures and objects which would interest them.

All this time I looked upon them with great pity and regret because they were so unfriendly to our government, rejected our education and scorned Christianity. To mention these subjects just was not done because of the hostile feelings of their parents. I felt very deeply about the wrongs that were being instilled in these beautiful boys and girls. I was driven by an urge to devise some plan by which I could acquaint them with our civilization without offending their parents.

My task was made easier because of their love of pictures, music and their curiosity in learning about new objects. I taught them all the kindergarten songs, pronunciation and meanings of many words beneath the colored pictures. Many times they would ask me to pronounce their words, which I could not, and they would be convulsed with laughter at my ignorance. This took away the seriousness of the occasion and they did not realize what was going on.

Later, the Presbyterians learned of their interest and furnished me with richly colored Bible pictures for beginners. Encouraging them to spell and pronounce the titles on the Bible cards was the beginning of their education and their introduction to Christianity ... Early in my work I was convinced they needed to replace the Great Spirit with Christ.

While Ivy's sense of mission appears culturally presumptuous now, it was perfectly consistent with the prevailing philosophy of her times. It wouldn't have been reasonable for her to have assumed that the Seminoles had any cause for the anti-white bias she refers to. Ivy acted in what she thought were the best interests of the Seminoles throughout her life. Child-

less, for reasons she never wrote about, her devotion to the Indians gained her the title "Watchie-esta Hutrie" or Little White Mother, an honorific that's still connected to her today.

My Dear Sister/
My Dear Friend

In the late 1870s and early 1880s, four girls grew up knowing each other along the shore of Biscayne Bay. Two were half-sisters—Mary Sullivan Barnott and Alice Oxar—and two were sisters who grew up and married brothers—Della and Delia Storman Keen. Living in the pinewoods and palmetto scrub north of Miami, their families literally dug a living from the earth by grinding the roots of the coontie palm to make and sell starch. They had little, if any, formal schooling, and were basically ordinary working-class women. But these ordinary women wrote extraordinary letters.

The women's common bond was Mary Barnott, who kept the letters her friends Della and Delia and her half-sister Alice wrote to her in the 1890s. Alice's letters, written in the early part of that decade, show flashes of a young girl's tempestuous spirit. They reflect some of the problems in living at home that Mary herself had probably once felt. Della and Delia's letters, written in the late 1890s after they had married and become mothers, reveal their problems with birth control, men, and hard times.

Mary and Alice's mother, Elizabeth Sullivan, had come to Biscayne Bay as a widow in 1868. With four-year-old Mary to raise, she soon married Michael Oxar, despite their age difference; he was forty-nine years old, she twenty-one.

Alice was born in 1873, and it's likely that Mary

helped take care of her and the half-brother and half-sister who followed. But Mary supposedly did not get along with her stepfather, so either to escape her family or because it was economically advantageous for her to marry, Mary wed Edward Barnott in 1877. Like her mother, she chose a much older man. Edward, variously a keeper at Biscayne Bay House of Refuge and also a starch-maker, was about thirty-seven years old while Mary was about thirteen.

Despite the nine-year difference between Mary and Alice and the separate households on the flatlands behind northern Biscayne Bay, the girls remained close. Writing around 1891 and 1892 when she was about eighteen years old, Alice shows herself to be an independent character which probably accounts for her frequent references to feeling trapped at home. One of Alice's few completely dated letters, written on January 22, 1891, alludes to her loneliness and to an issue of Mary getting her "rites" in some unexplained legal/financial matter.

My Dear sister,

You asks me if I get lonesome. I get so lonesome some times I dont [know] what to do. Maggie [her younger sister] is gone all day most and you no [know] papa does not stay in the house much. I am lone most of the time. I dont no what I would do if Dorcas [Dorcas Perkins, listed in the 1880 Census as a black servant] was not here and she is sick all the time . . .

You say some one is all the time makeing [making] trouble for you. You only think so. Why dont you sell some land and by a horse. If you had gave Quimby [the county clerk] the money you gave Jimmy you would have your horse now. Mr. Quimby said you could have got it for five dollars as he was positive the horse was yours . . .

Sister, dont get mad but Mr. Quimby was doing the best he could for you til [until] Jimmy

made him mad. You no [know] we can not get our rites [rights] some times. I think you had better give up the horse for good and buy one.

The identity of Jimmy is unknown here, but John Peden, a bachelor, whom Alice frequently writes about, is identified. As Mary Barnott's neighbor, he may have taken some of his meals at Mary's house either as a guest or in return for some kind of payment—money or food such as the occasional chicken. Alice pokes fun at Peden a lot in these letters.

Tell Mr. Peaden to give you my share of chicken for I dont like it, Tell him I cant get him no girl but Mame Roberts. Bueaty [beauty] is only skin deep. Any way I think them Dofit boys is born fools. I think Mr. Peaden might get one of the girls. But I think he will die single. No matter how wel [well] a girl loved him when he would ask her it would make her sick of him.

Both Mary and Alice were good gardeners, growing flowers and vegetables, and they'd often exchange news about their gardens. In another partially dated letter—23, 1891—Alice is a little contemptuous of John Peden's agricultural advice and she also hints at problems at home.

Another unclearly dated letter continues the teasing references to Peden's bachelorhood while hinting at Alice's own plans to marry Will Baldwin, a fisherman, whom she married in June 1893. Alice's letter also suggests that despite being married, Mary had attracted the attention, or at least flirtations, of other men.

Charlie [her brother] and Will [Baldwin] has not come yet. Maggie [her sister] is talking so I cant write. She is teling [telling] me how she is going to kiss Will when he comes.

I am going to tease you now . . . You said you was going to get a feler [fellow]. Have you found one. Why dont you do the same as I do keep the same one . . .

Tel Mr Peaden I aints going to wait eny longer for him to get a girl. I will get him a girl if I can. He told me to wait til [until] he got a girl and have to weddings [two weddings] but great Scoot [Scott] he takes to [too] long. I will wait one year more for him. He cant get Fannie I no. Tel him I say he must ask one of the Dofit girls.

Alice might joke about her sister and about Mr. Peden but there were also very unhappy times. One letter with just "Miami 28" written on top speaks of her being "wild as a hawk" and having "fell out with everyone but myself."

. . . Dear sister, I wanted to go an see you but you no how papa is. He wont let me go no where. I get so mad some times that I dont know what to do.

. . . When I get married I will go where I like. I will come up and stay with you and we will have a gaye old time. I want to obey my parents now and do the best I can for them in there old age.

He came to convert me—I am worse now and [than] I was before. Willie Pent bought him. I left them in the yard a singing Nearer my god to thee. I thought they was getting dam near when [they] came hear. I would not ask them in. Mother did and then they went a board the boat a cruising.

Have you heard eny more lies I told on you? I think you are a pretty sister. [Don't] believe everything you here. I see you have no more faith in me and [than] Papa has. Never mind some of these days I will have some one that will trust me. Don't you think so. I have fell out with everybody but myself.

As long as I stay with them I can't go no where so I am going to stay at home and see if I can't be a good girl and sister cant you come down to my birthday. See if you cant come. I will look for you.

What do you think? They say I am a tom boy and a flirt. I am getting well now and this norther [a storm] makes me wild as a hawk.

What kind of church did you have that day? The dam fool came here and praed [prayed] and sang so hard that the house leaks so bad that you cant stay in it. We have to go outdoors to keep dry when it rains ... I expect to hang myself some time. I would have done it long ago but I have bin wating [waiting] for somebody else to do it. I must stop my foolishness but it makes me mad to think that you would be live [believe] the lies they say on me. A kiss for all the little ones and one for you. Be sure and come the 6 of November.

While the sequence of Alice's letters to her sister Mary can only be guessed at, their mother's death on July 27, 1892 is probably the outer limit for their time frame. Elizabeth Oxar's death in her mid-forties was also the occasion for Mary to write her husband Edward from her mother's home. It's the only available letter in her handwriting, and it's remarkable for how much the unvoiced feelings say in it.

Dear Edward
Come home with the little ones. Poor mother is dead. Come to me and bring my black dress and white apron out of the trunk and make the children put on clean close [clothes.] Tell Mr. Peden.
Come.

Mary.

When her mother died, Mary had four children and was pregnant with her fifth child who was born three months later in October 1892. A sixth child was born in 1893, and Mary may have been expecting her seventh child, Oliver, when Della and Delia Keen's letters to her begin.

Della and Delia had moved to Fort Pierce around 1885 after their father John Storman had died and their mother Martha remarried. According to family legend,

they made the 110-mile trip north in an ox wagon and on foot. Fourteen-year-old Della and twelve-year-old Delia took turns carrying their baby half-brother Melvin Green in their arms.

The girls went to work at a hotel in nearby Jensen Beach, and there, by coincidence, they met and married two brothers, Joseph and James Keen, within months of each other in 1888–1889. The Keens had come to Florida to grow pineapples; later, they'd hire out as hands on cattle drives, haul wood, and do other physical work.

Yet the girls maintained an interest in their Miami friends, and particulary in Mary. At the time Mary began keeping their letters, twenty-three-year-old Della was expecting her third child; her first two daughters were four years old and two years old. Delia was twenty-one years old and had two sons, also four and two years old.

By 1900 when traces of their correspondence stop, Della would have five children and Delia would have four, so it's understandable that much of their letters would revolve around sex, children, and men. None of Mary's responses to them remain, but certainly she would have been a sympathetic listener since between 1883 and 1896 she herself had eight children who lived to maturity. Other letters and some interviews Mary later gave suggest that she may have borne and buried seven more children before 1900.

Mary's large number of pregnancies was not really that typical during the late nineteenth century, and Della chides her in one letter, "I thought you was old enough to quit such foolishness as that."

Contrary to popular beliefs about large Victorian families, medical historians estimate that the birth rate for native-born white women actually fell in the 1800s from an average 7.04 children in 1800 to 5.21 in 1860 and to 3.56 in 1900.

A reason for the decline was the availability of birth control. By 1865 rubber condoms, vaginal diaphragms,

spermicidal douches and the rhythm method had all been described in popular journals; they must have been sold and advertised to some degree because the 1873 Comstock Act banned sending them or "any drug or medicine or any article whatever for the prevention of conception" through the mails. The prohibition applied both to the item itself as well as to any advertisement for it.

While some women shared in letters what they knew about preventing or remedying unwanted pregnancies, they had to have access to such information in the first place. But the Keens and Mary both grew up in isolated, rural areas, had little access to medical care, and probably delivered their babies at home without benefit of a doctor. While they wrote, it's doubtful how much they read. So the only birth control method suggested was abstinence which wasn't entirely favorable to women. "It does not matter how ugly the man is— the woman loves to look at them just the same," writes Nancy Storman, Della and Delia's sister-in-law, also a correspondent of Mary's.

Della's first letter to Mary, dated December 10, 1894, has a note of commiseration:

> My dear friend,
>
> I was very sorry to here [hear] how bad the storm had don [done] you all but I hope you will get along allrite again.
>
> Well, Mary I think that you have got enough of little ones. You shud [should] not have so many and times so hard but I guess you are like I am. If you could stop you would if you could.
>
> I have not got but too [two] now but I think there is something the matter now. I hope that I will never have another one. I rether [rather] be ded [dead] than to no [know] that I was that way again. I dont think that I could ever stand it again
> . . .

Indeed, Della's third child, John, was born in July 1895, so she had probably skipped one menstrual

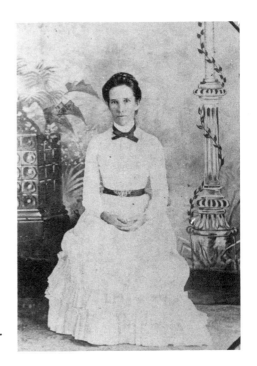

Della Keen.

period when she wrote this letter. But in her next letter to Mary, she writes more about the hard times her family was facing. Henry Flagler's railroad had come through Ft. Pierce, but because he hadn't developed the area, men were hired as needed and then let go. In her letter of June 17, 1895, this economic reality, not her impending childbirth, was on Della's mind.

> Well, Mary there is no news to write to you only the RailRoad is now stared [started] down there. When it gets down there [to Miami] I will come down and see you and I want you to come and see me . . .

> I hope it wont hurt that place like it has this. The men cant get a days work now. I hope times will get better. If it dont I dont no what we will all do . . . Mother is not well. She has the tooth ack [ache] all the time. She cant get any thing to do it any good. If you no [know] anything that is good for it please write and let me no.

Delia Keen with her husband Jim and sons George (b. 1890), Corbett (b. 1892), Robert (b. 1896), and John (born after 1900.)

Mary, I am sory [sorry] to here [hear] that you and Alice cant get along to gather [together]. I no how that is for too sisters to be mad at each other and some women will get mad with her best friend if her husband tells her to. Delia is out to Mothers now [west of town]. I am looking for her to come home to day . . .

Delia's first letter to Mary, written on September 15, 1895, three months after her older sister Della's, continues the refrain of hard times.

Well, Mary, it is the same old thing. Thay [there] aint any thing that is funny up here only hard times that is geting [getting] to be funny to think abut [about]. Where thay [they] are going to get something to eat. I hope you will have something to tell me that is funny.

But Delia who was younger than Della and Mary also enjoyed a good gossip and, at times, her writing is almost risque.

I wish I could see Miss Wetherford [a Miami woman they both knew]. I think I could tell her abut [about] how nice the bride to be [was] when I was down there [in Miami]. I hope I will never get to be like I think she is. If I was that, Mary, I would be glad if nobody would spike [speak] to me. I think all the men must have a hart [heart] to take a old wore out thing like she is. What do you think abut [about] it? If I was the men and could not get any better than she is I would go off and put my Darn old thing in a hollowlong [hollow log].

You must write and tell me all the news down there. Thay [there] aint any news up here worth any body knowing it. Thay may be plenty of [it] but I dont see any one to find it. I stay at home all the time. I dont go any where . . . only out to Della and to Mothers when I can get a chance. I am one by my Self and I guess I will stay that way and then maby [maybe] the people cant find so much to talk abut . . .

Twenty-two-year-old Delia was doing more than talking about geographical isolation here. Apparently like Mary's younger sister Alice, Delia also got into family disagreements that left her cut off from social contacts, especially with her brother John Storman and his wife Nancy.

Mary, I no you feel sorry for me. John and his wife is . . . [going away] soon but it dont worry me any in the least . . . [H]is wife told the lie and now thay want to blame me with it and when thay come over to me they are going to get some thing they wont like very much. Thay had better no [not] fool with me for I wont take any of it. I have been run over just as long as I am going to be.

Delia's next letter to Mary continues this mood of self-pity: she's still fighting with relatives; her husband is away from home either hauling freight in his wagon or working on a cattle drive; and she's "gone up" or

pregnant again. "I have been wating for something new to tell you but I can't find a thing," she begins on November 15, 1895 and then proceeds to write what's happened to her.

It is the sime [same] old thing with me. I am yet by my Self. You can bet I enjoying my self staying by my self. My old man was at home last week but is gone again. It is sich [such] hard times until it takes all we can do to live . . .

I hope you are having a good time for I am not. I never excpt [expect] too any more.

Mary, it is not no joke abut [about] me be gone up again. I am so fat until I cant hardle [hardly] walk now and I dont know how I will look by the time I get down [give birth].

I dont excpt [expect] to get over with it untill [until] next March. I have got a long time yet to think over it. It dont worry me very much for I no [know] the one that has carried me through all the times will carry me through again so thay aint any use for me to worry my life a way over it. What do you think? aint I rite? . . .

Despite this tone of piety, Delia was downright snippy when she writes about her brothers and sisters-in-law in the same letter.

Frank [her second brother] is in here today. He hasent [hasn't] found any baby yet but he thinks he will find one abut the first of the next month. [Franklin and his wife, Indiana, were expecting a much longed-for child].

I no [know] he will do something when he does find one. I dont think he will ever be able to do any thing more. He dont think any one has got a wife but him and when he gets a baby I no that will fix it all. Well, thay can all be fools abut babys that wants to but I dont see any things funny abut it.

You said John [Delia's oldest brother] told you he did not want a baby but that is a big story. He

wold [would] give his hole [whole] life for a baby
and his wife is worse of [off] about one than he is.
He noes [knows] it is no use to want one for he
has tride all he could to make one and all the rest
of the men has trying to help him out but none of
them can do any good so I no he will never have
the trouble with one and it is a good thing for
him.

Yet once she's done casting aspersions on her sister-
in-law, she returns to her major concern:

Mary, if I can just have a boy I wont care but I
dont want any girl in mine if I can help it. Boys
seem anuff [enough] trouble and girls seem more
than boys do . . .

Christmas 1895 brought little excitement to either
Mary's family or her friends in Ft. Pierce. "It is very dul
times for it to be so near Christmas," Della writes on De-
cember 18, 1895, noting that the only news is that she
and her five-month-old son John had been sick and
that a drunk had fallen asleep on the railroad tracks
and been run over by a train.

"I was very sory [sorry] to here that Mr. Barnott was
so leam [lame] with his foot and leg for I know how it is
when the man of the house gets sick. It seams [seems]
like every thing stops then," Della adds.

The new year finds her still dealing with a teething
infant. There's more news about babies and pregnan-
cies and some thoughts about child-rearing. But al-
though Della's letter of January 13, 1896 begins with
almost a formula salutation, "there is no news up here
only hard times," there's no sense of self-pity in her
writing.

. . . No news . . . only plenty of barths [births].
There was a woman had a baby last week and it
only lived four hours. The woman went to sleep
and when she waked up her baby was ded. They
said she [probably a premature infant] was only
seven months.

Frank [her brother] and his wife has found a

baby at last. It is three weeks old. It is a girl. He said that he wanted it to be a boy but it was not so he said that he thought as much of it as if it had bin [been] a boy. Frank thinks that no one else never had a baby but him. He has named it Pearl. He says he will bring his wife and baby down to see us as soon as he can: I tell him when he as [has] as many as I and you he will not think it is so funny. . .

Poor Delia she has not bin [been] able to git out of bed for two weeks and I dont think that she will be able to do any thing any more untill she gets all rite [Delia was due to give birth in March 1896]. Her husband is gone all the time and she has too much to do.

Delia's husband was often away because of work. But Mary must have questioned Della about the way Delia treated her two sons George, age six, and Corbett, age four, after seeing them on a trip to Miami.

"You asked me if she whiped [whipped] her too [two] little boys as much as she did down there," Della continues. "She whips them a rite smart now but I dont think that she will when she gets all rite. She is mity [mighty] ill now. Mother has come down to stay a while with her."

In response to another of Mary's comments, Della writes,

Mary, you are just rite about the whisky. I dont like it my self. I think it is ofel [awful] to see a man drink whisky and we must try and teach our children to hate it all we can. We must do all we can while they are under us and then if they do bad when they get grown we are not to blaim [blame] so much for it.

I think that you are trying to rasing [raising] your little ones just rite. I went to the Christmass tree with my little ones. It was very nice. There was not any one drank as I saw but the next nite they had a dance and they told me that very near

every man was drunk. Too [two] men had to fite [fight] and they hurt each other pretty bad.

Well, I guess you and me has seen all of our fun now. [Della was twenty-five years old and Mary was thirty-two years old.] We have got too many childern to go [out] very much. We must stay at home and take care of the little ones.

I want to raise my little ones what I have got but I hope the good lord has give me my lass [last]. If I can live to raise them, it looks like I have got all that I can do any thing with. I dont want so many if I can help it.

I hope he will have pitty [pity] on me. . . Mary, if I could see you I could talk with you all day and all nite but I cannot write very much. It is time to start dinner now so I will stop.

But Della couldn't "help it." She had probably just become pregnant with another son, Robert, who was born in August 1896 and then she would have another daughter, Cornelia, in 1900. Meantime, Delia was nearly ready to give birth to her third son, and her pregnancy wasn't proceeding easily, as she wrote on January 25, 1896. Still, she was able to continue her verbal vendetta against Nancy Storman, her brother John's wife.

You must not think hard at me for not writing before now for I was in bed sick when I got your letter and have been sick for two weeks but I am a little better now. Ma has been with me for three weeks but she is going home this week and I dont no what I will do when she is gone. I guess I will get along some way.

You said you wish me a happy new year. It was not very happy to me for I was in bed sick but I hope you had a good time. Well, Mary, just think I have got two more month[s] to go yet before I get out of my troble [trouble]. It dont seem like I can bear it that much longer. If I felt well I would not mind it so much but I am no count for nothing.

. . . Have you seen John [her brother] down there? His wife makes out like she cant stand it if he dont come home but I dont think she cars [cares] very much abut [about] him. She said she had writin [written] for him to come home but I see he has not come yet nor I dont think he will until he wants to. She must be afraid he will find a girl down there and I guess it would be a good thing if he would. . .

Write [me] long letters for I . . . will have plenty of time to read here . . .

Obviously, something must have been going on with John and his wife because the next letter from Della on February 29, 1896 has her speculating over the matter for the first time. Through the letter, we also learn that Mary was "gone up" or pregnant with her eighth child, Thomas. "I don't know what you are thinking about . . . It looks like Mr. Barnott would get to [too] old after a while," Della writes, referring to Ed Barnott being about fifty-six years old.

My dear friend,

. . . Brother John has got home at last and I teased him good. You bet he thought so much of his Girl untill he wanted to go back down there with the Mr. Hendrys [owners of the beef cattle herd that the Keen men worked with] but he says he is coming down there [to Miami] soon.

You must write to me the Girls name he went with . . .

I am awfull sorry to hear that you are gone up again. I dont know what you are thinking about. I thought you was old enough to quit such foolishness as that. I do hope you will have a good easy time.

I am truly sorry for a woman in that condition. Well, a Poor Woman catches it any how. Dont they? It looks like Mr. Barnott would get to [too] old after while.

Yes, I have got a Good husband. He is kind to

me. If I dident [didn't] have I dont now [know] what I would do with a mean one. I guess I would break his legs for him and leave. Jack [her husband] is like Mr. Barnott. Whatever I say is all right with him. Any thing suits him. . .

Della had good reason to wish Mary "a good easy time" with her pregnancy. Some statistics show that deaths from maternity-related causes at the turn of the century were about sixty-five times greater than they were in the 1980s. Delia Keen may have been exaggerating about her recent delivery of her son, Robert, in this letter dated June 6, 1896, but the risks were real.

I will try to write you a few lines to let you no [know] I am not dead but I am near it. I no you thought I was but I came out all rite. I hope I will never be that way again.

Well, Mary you did not get your wants. You said you wanted it to be a girl but it aints [isn't]. I have got three boys and I think thay are just as bad as thay can be.

The baby is cross. I can't get time to write much. I am not very well yet but I hope I will get strong after a while.

Mary, I had a bad time when the baby was borned. For a little one I would of [have] been gone to rest [died]. He waid [weighed] nine pounds when he was borned. He is tow [two] months old and he looks like he was about six . . . He is just as smart as he can be.

Well, I can tell you I dont want any more of that in mine. I don't think I could stand more . . .

The last letter Mary kept from her Ft. Pierce friends was written by Della, shortly after Mary's husband had died. Only fragments remain and because Mary's part of the correspondence is missing, it's natural to wonder about the gaps of information. It's obvious that Mary was concerned about taking care of her family and that her friends were trying to advise her.

In writing on June 2, 1900, Della drew on the

Even in the 1900s, pregnant women were rarely photographed. But Edith Mercier Conklin was happy to have her picture taken shortly before her daughter Dallas was born in 1907. The baby was named after Ft. Dallas Park, the Miami area her family lived in.

experience of her mother, Martha, who was fourteen years older than her second husband, Andrew Green. At the time of this letter, they had been married nineteen years: she was fifty-six years old and he was forty-two.

My dear friend,

. . . Was glad to here [hear] from you and to here [that] you all was well and getting along well. I hope that you will keep all of your children at home with you and let no man harm them for I wood [would] kill any other man if he was to hit my children. I think if [you] are getting along all rite that you had better let well enough alone.

Mother sayed [said] to tell you for you to stay single for she have not bin happy in a good many years. For if you mary a young man that can help you he will not do like you want him to do and if you marry and [an] old man he will not be much good to you. So she sayed that [if] you was getting

[along] . . . that she would stay single but you can do as you think best.

You can tell I think that you are old enough to tell which is best . . .

You wanted to no what my husband done for aliven [a living.] . . . He has three mules and a horse—he hals [hauls] wood and eny thing that is to be halled. He makes a very good liven at it . . .

Well, Mary, my baby is three months old now. It is a little girl [Cornelia]. She is well and growing very well. She was small when she was born. I have not [weaned] her yet . . .

[You] must write back as soon as you get this . . . I am as ever, your loving friend Della Keen.

In 1902, Mary Barnott married again. Following neither of the extremes mentioned by her friend's mother, Mary's choice this time was someone closer to her own age. John Peden, her long-time friend and neighbor, was about forty-three years old and Mary was about thirty-eight years old. Together, they had a daughter Helen, born in 1904. John died in 1920 while Mary lived until 1948.

The 1910s

I n 1912, Henry Flagler's Florida East Coast Railroad
reached land's end at Key West, the southernmost
tip of Florida, and the initial push of pioneering and
settlement in south Florida ended. There were motor-
cars on the roads, telephones in homes, and young
boys who'd deliver customers' groceries on bicycles. It
was a far cry from Margretta Pierce's lament over no
fresh beefsteak, butter, or buggy rides nearly forty
years earlier on Hypoluxo Island.

But some things about the south Florida landscape
hadn't changed. Shirley O'Neal and her husband made
one of the first long-distance automobile trips down to
Delray from Nebraska in 1913. Some of the observa-
tions made along the way weren't so different from
earlier ones:

Friday, December 5

We are in camp just across the bay north of
Stuart. Had awful roads . . . same performance
of dodging trees and plowing through the sand.
Got late start as we waited for the tent to dry off.
Heavy dews every night [so] our bedding has
been damp all week. The mosquitoes are so
thick we can hardly breathe and a tiny gnat in
great numbers is viciously biting us. (And they
say there's no insect pests in Florida.)

Saturday, December 6

In camp at Lake Worth . . . found good roads

all the way down but no groves or crops of any kind. Passed through West Palm Beach which is a pretty little town about 2:30 P.M. Got our deeds and came on down here. It's raw and new here. No gardens—no cows—no poultry—but a great plenty of real estate men . . . It's almost too warm here and very much too dirty.

Raw, warm, and dirty it may have still been in parts of south Florida but the real estate agents the O'Neals noticed found lots of northerners interested in buying land. Maude Holtslaw, for example, came to the town of Lake Worth in November 1911 with her husband and children to join her parents who owned the Illinois Farm. Not really a farmer, Charles Holtslaw worked as a land surveyor and spent part of that first year living in a West Palm Beach rooming house and commuting home periodically to Maude and the children in Lake Worth.

Maude herself didn't work outside the home but the way she spent her time shows that not much had changed for some working-class women. At the farm, on the southern edge of Lake Worth, she helped weed, pack, and sell the produce with her mother in nearby West Palm Beach.

Friday, December 1, 1911

I took my first lessons in cleaning and packing grapefruit. I think I'll like it fine. We got twelve crates packed . . .

Wednesday, December 13, 1911

CHH [her husband] and I burned brush for planting beans

Friday, January 5, 1912

The children and I picked mulberries and had pie for dinner. I sowed more radishes . . .

Monday, January 15, 1912

CHH, Charlie and I worked all day with peppers and egg plants, getting weeds out . . .

Her tersely written journal for the year shows a life of hard, tedious, daily work. She did cooking, cleaning,

including washing the floor with coal oil to kill the fleas, and took in boarders. Maude also made much of the family's wardrobe. During the year, she sewed four dresses for herself, two suits for her son Dwight, and clothes for her daughter Florence. But what really occupied most of her time was laundry. Of the 318 entries she wrote for the year 1911–1912, she spent about eighty days, or almost three months, either washing or ironing. Even a June flood didn't interfere with her chores.

Monday, June 10

Water, water everywhere and not much to drink. When we got up this morning there was water everywhere. It was up to our steps. CHH had to carry his father out to the road, then he and Pickering built a walk.

About sixty men worked all day trying to drain off the water.

Wednesday, June 12

Still water. We peeled and canned pineapples this morning. I bought fourteen for fifteen cents. I took a terrible headache and went to bed. Had taken medicine last night and felt bad today. The Chick family were out in their boat. [Local newspaper files from these dates have been destroyed but apparently the waters were so high that people rowed down the streets of Lake Worth.]

Thursday, June 13

Water still pretty high. Lots of men working on the ditches . . . I washed about half of the dirty clothes.

Friday, June 14

I washed the rest of my washing. Before I got them ready to hang them out they had opened the water [on the flood gates of a nearby canal] and it filled our back yard so I had to wade in water to my knees to hang them out and gather them in.

For entertainment, there were occasional Sunday picnics at the ocean, and the family traveled to nearby West Palm Beach where Maude heard the town band three times and went to the movies twice. (West Palm Beach, at that time, was a big city of a few thousand people compared to Lake Worth which had a population of about 370 residents.)

But, overall, the tone of Maude's journal—even when she's describing happy times such as this Fourth of July picnic—is flat and almost dull.

Thursday, July 4, 1912

Glorious Fourth. About 500 people here [at the beach]. Lots and lots of good stuff to eat. A trip to the ocean and surf bathing. Ending up with a fine display of fireworks.

Friday, July 5, 1912

Well, the 4th is over but my how tired I am. Didn't do much all day but rest.

Sadly, most of Maude's life that first year in Lake Worth is epitomized by what she wrote for her birthday.

Friday, August 2

My 26th birthday. I celebrated by washing most all day. Spent the rest of the day feeling pretty miserable.

But between the bleak life of the Holtslaws and the opulence of Palm Beach, falls the experiences of Johanna Vallowe Slater, who began coming to West Palm Beach in 1908 with her husband and five children. At first, they made the trip by train, but later, when automobiles became more popular, they drove from their Pittsburgh home to West Palm Beach in eight days.

Originally, they stayed at her brother Henry Vallowe's wooden frame house near the shore of Lake Worth. Henry Vallowe was a musician who played in the town's band, and his middle-class household included the services of a laundry woman. In unpublished family memoirs written in 1958, Johanna recalled how she hired Susie, the laundress:

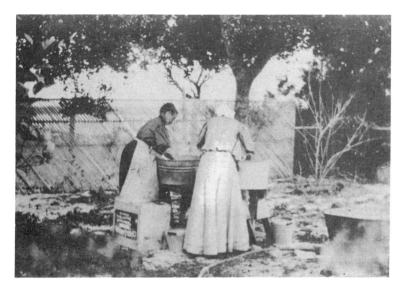

Washday, circa 1910.

The section beyond the gate to Dixie Highway was not cultivated and still in a wild state; it contained a small cabin, occupied by a young colored couple, Kergus and Susie. Kergus owned and manipulated an Afromobile, a bicycle powered sight-seeing wheelchair. Susie did our laundry-work outdoors in a large, black kettle.

Our first conversation on asking if she wished to do the work was like this—"Yes, mum, does you furnish the soap?" [Then] on assenting, "Does you furnish the starch?" The soapine [a strong detergent or bleach] or whatever we did *not* furnish, managed to dislodge the coloring from so many things that we scarcely recognized our clothing on their return.

Johanna and her family frequently went out in her brother's boat.

. . . We'd troll for fish . . . or [sail] to the Royal Poinciana Hotel on Lake Worth and the Breakers Hotel on the ocean. The two were connected by a beautiful promenade, less than a mile in

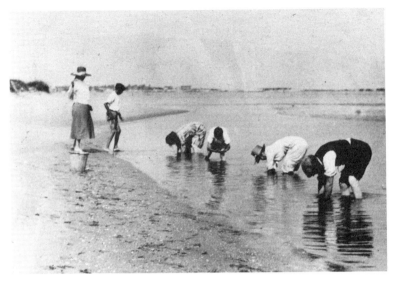

Johanna Vallowe Slater and her family picking clams, circa 1912.

length [with] a center track of rails over which
was manipulated a donkey-drawn cart for those
either too young or old to walk.

Another treat was gathering oysters in Lake Worth.
Brother and husband would put on boots with
which to kick them loose as they grew in clusters
and were hard to dislodge. We were always
happy to have sea foods as refrigeration as we
know it today was almost non-existent and meat
not satisfactory in this warm clime—so, a wel-
come change were the oysters, clams, soft shell
crabs, and even wild ducks they returned with.
To help things along, Niece and I with the aid of
a large Bobbin, made an immense circular cast-
ing net for brother, which was used for getting
bait for fishing, out of a heavy cord on the order
of tatting.

Johanna also wrote of land sales in the first decades
of the century.

When the Royal Palm Bridge was built near the
lake end of Okeechobee Road there was a busy

*Johanna Vallowe
Slater biking.*

time on the Palm Beach side selling lots . . . An almost daily sight was groups of people, gathered around a truck, listening to a speaker and a band tooting out the melodies. Gifts were handed out by the dozens—I remember one tray handed to me had a glass top over a floral cretonne and a mahogany rim.

Lots on the [Palm Beach] side seemed to have homes spring up on them very quick; on the West Palm Beach side of the bridge, known as Phillips Point, the band-playing did not seem to have the same effect and for years it lay forlorn and neglected.

By the mid-nineteen-teens, the Slaters were renting a house in downtown West Palm Beach and her children went to school on bicycles ordered from Sears, Roebuck.

Oldest Son played cornet very well and as

Brother played flute in the West Palm Beach Band, he induced Son to join for the Winter Season, so at fifteen years he earned fifteen dollars a week, which was a fortune for him.

Brother remained on his premises the rest of his life—we returned to our northern home but came back many winters, sending our children to the West Palm Beach schools, renting, at least, half-a-dozen homes, furnished in as many different years . . .

Over the span of those winters, Johanna saw many changes, including the naming of a street in downtown West Palm Beach—Vallowe Court—after her brother. She ends her account on a nostalgic and upbeat note:

We enjoy seeing all the growth and progress today in the Palm Beaches, but look back with great pleasure, to the Pioneering days of "roughing it" fifty years ago!

But not everyone takes such a sentimental approach to the past. In writing how an 1896 shipwreck was a symbol of the outside world to her, Lillie Pierce also describes propping up her baby daughter with a pillow so she could rush to the beach. That baby girl, Freda Voss Oyer, later described her own childhood on Lake Worth around the turn-of-the-century in very realistic, though still positive, terms.

We didn't [think we were] enduring anything . . . We were perfectly happy and thought we were having a perfectly nice, normal life because we didn't know enough [to know] we were being deprived of anything.

Of course, it was primitive. There were no bathrooms. We had [an] outhouse and wash-bowls and used a washboard under a tree. [But] we didn't realize that we were being, what you would call now, deprived, because that's the way everybody else was doing.

It's important to hold on to this honest view of the past, rather than romanticizing it, because to do

otherwise would somehow diminish the real lives of these pioneer women. They struggled on a daily basis to create comfortable lives for their families in a climate that wasn't always physically hospitable. Those who stayed, and most of those who left papers behind did, overcame the loneliness that accompanies all pioneers who set out from familiar homes.

If we filter their lives through myth or stereotype and turn them into "sunbonneted weepers" or "brave adventurers," as historian Lillian Schlissel calls them, we make them into fictional characters rather than real people. These women and girls were not heroines in the classic sense although parts of their lives may have been heroic. They laughed, sweated, wept, and bled. These early women took time from chores to write about their daily lives, about the tragedy and laughter they experienced, and the beauty they were able to perceive. Without their written records, the reality of pioneer life would be flat, two-dimensional, and much harder to imagine.

Bibliography

Barnott, Mary. Letters. In personal collection of Dr. Thelma Peters.

Carpenter, Hattie. Letters, ledgerbook, personal reminiscences (typescript). In the library of the Historical Association of South Florida.

Catlow, Patty Munroe. "Growing Up at the Barnacle" in *Update,* June 1977, and personal interview, August 1987.

City of Miami Directory, 1904. In the library of the Historical Association of South Florida.

Connelly, Flora Hill. "Early days in the Homestead Country." Typescript in library of the Historical Association of South Florida.

Dean, Sarah Moses. "Growing Up in West Palm Beach." Typescript in the library of the Historical Society of Palm Beach County.

Gilpin, Emma. Letters and journals. In the library of the Historical Society of Palm Beach County and the library of the Historical Association of South Florida.

Holtslaw, Maude. Diary, 1911–1912. In the library of the Museum of the City of Lake Worth.

Junkin, Carolyn. "Stella Budge's Family History." Typescript in the library of the Historical Association of South Florida.

Keen, Delia and Della. Letters. In personal collections of Dr. Thelma Peters and Mrs. Bessie Wise, grand-niece of Della Keen.

King, Susan. Personal reminiscences. Typescript in the library of the Ft. Lauderdale Historical Society.

Lyman, Daisy. "Teaching in West Palm Beach." Typescript in the library of the Historical Association of Palm Beach County.

Miller, Florence. "My First Winter in Florida." Typescript in the library of the Historical Association of South Florida.

Munroe, Mary Barr. Diary. Microfilm. University of Miami.

Myers, Ruby Andrews, ed. *Lake Worth Historian.* A souvenir journal published by the ladies of Palm Beach, 1896. In the library of the Historical Society of Palm Beach County.

O'Neal, Samuel and Shirley. Travel diary, 1913, and postcards. In the library of the Historical Society of Palm Beach County.

Oxar, Alice. Letters. In personal collection of Dr. Thelma Peters.

Oyer, Freda Voss. Personal papers. Typescript in the library of the Boynton Beach Historical Society.

Pallicer, Lula Marshall. "Pioneering in Ft. Lauderdale." Typescript. In the library of the Ft. Lauderdale Historical Society.

Sanders, Susan. "The New Schoolteacher." In *Ancestry*, July 1981.

Simmons, Dr. Eleanor Galt. Letters. In the library of the Historical Association of South Florida.

Slater, Johanna Vallowe. "Early days in West Palm Beach." Manuscript copy in the library of the Historical Society of Palm Beach County.

Spaulding, Arthur. Letters (typed) In the library of the Henry M. Flagler Museum.

Stowe, Harriet Beecher. *Palmetto Leaves*. A fascimile reproduction of the 1873 edition. Gainesville: University of Florida Press, 1968.

Stranahan, Ivy Cromartie. Personal papers, letters. In the library of the Ft. Lauderdale Historical Society.

Thompson, Florence Murray. "Autobiography." Manuscript in possession of Mrs. Thompson's daughter, Barbara Hutchinson.

Voss, Lillie Pierce. Letters and papers. Typescript in the library of the Historical Society of Palm Beach County.

Williams, Ethel Sterling. Papers, typescript biography, oral history. In possession of Mrs. Williams' grandson, William S. Williams.

Additional Reading

For south Florida history:

Coulombe, Deborah A. and Herbert L. Hiller. *Season of Innocence, The Munroes at the Barnacle in Early Coconut Grove.* Miami, Fla.: The Pickering Press, Inc., 1988.

Kleinberg, Howard. *Miami: The Way We Were.* Miami, Fla.: Miami Daily News Inc., 1985.

Linehan, Mary. *Early Lantana: Her Neighbors and More.* St. Petersburg, Fla.: Byron Kennedy and Co.

Parks, Arva Moore. *The Forgotten Frontier: Florida Through the Lens of Ralph Middleton Munroe.* Miami, Fla.: Banyan Books, Inc., 1980.

Pierce, Charles. *Pioneer Life in South Florida.* Edited by Donald Curl. Coral Gables: University of Miami Press, 1970.

Peters, Thelma. *Biscayne Country: 1870–1926.* Miami, Fla.: Banyan Books, Inc., 1981.

Peters, Thelma. *Lemon City: Pioneering in Biscayne Bay 1850–1925.* Miami, Fla.: Banyan Books, Inc., 1980.

Taylor, Jean. *The Village of South Dade*. St. Petersburg, Fla.: Byron Kennedy and Co.

For anthologies and studies of women's journals about the westward journey:

Jeffrey, Julie Roy. *Frontier Women: The Trans-Mississippi West 1840–1880*. New York: Hill and Wang, 1979.

Riley, Glenda. *Women and Indians on the Frontier, 1825–1915*. Albuquerque: University of New Mexico Press, 1984.

Schlissel, Lillian. *Women's Diaries of the Westward Journey*. New York: Schocken Books, 1982.

Index

The Pickering Press Making Florida History

Other titles in the Florida History Series include:

Broadway By The Bay, Thirty Years at the Coconut Grove Playhouse, by Carol Cohan

Children and Hope, The History of the Children's Home Society of Florida, by Lawrence Mahoney

The Biltmore: Beacon For Miami, by Helen Muir

The Early Birds, A History of Pan Am's Clipper Ships, by Lawrence Mahoney

Hialeah Park: A Racing Legend, by John Crittenden

Season of Innocence, The Munroes at the Barnacle in Early Coconut Grove, by Deborah A. Coulombe and Herbert L. Hiller

Public Faces—Private Lives, Women in South Florida—1870s-1910s, by Karen Davis is available at all fine bookstores and also directly from The Publisher.

The Pickering Press
2575 S. Bayshore Drive, #3-A
Miami, FL 33133

TEL- [305] 858-1321
FAX- [305] 856-0873

About the Author

Karen Davis grew up in New York City where she graduated from the City College of New York. She received her Masters of Arts in Teaching from Harvard University. For the past twenty years she has been a magazine journalist covering women's issues. In 1978 she moved to West Palm Beach, Florida, with her husband and two daughters. Her interest in Florida history and eventual research led to the slide presentation entitled *Public Faces—Private Lives*. Initially funded by the H.F. Kaltenborn Foundation in Palm Beach, FL, this exhibit was underwritten by the Florida Endowment for the Humanities, and continues to tour throughout south Florida's libraries and historical associations. Ms. Davis is currently an Adjunct Instructor of Communications at Florida Atlantic University, where she has been teaching Journalism, Business and Professional Writing, and Creative Journal Writing Workshops for seven years.